Enduring Splendor

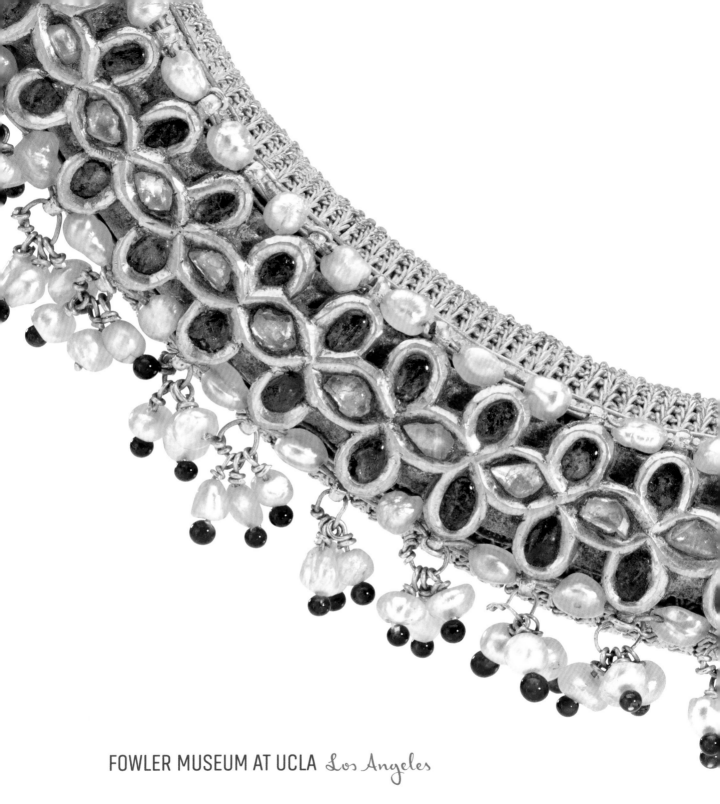

FOWLER MUSEUM AT UCLA *Los Angeles*

Enduring Splendor

JEWELRY OF INDIA'S THAR DESERT

Thomas K. Seligman
Usha R. Balakrishnan

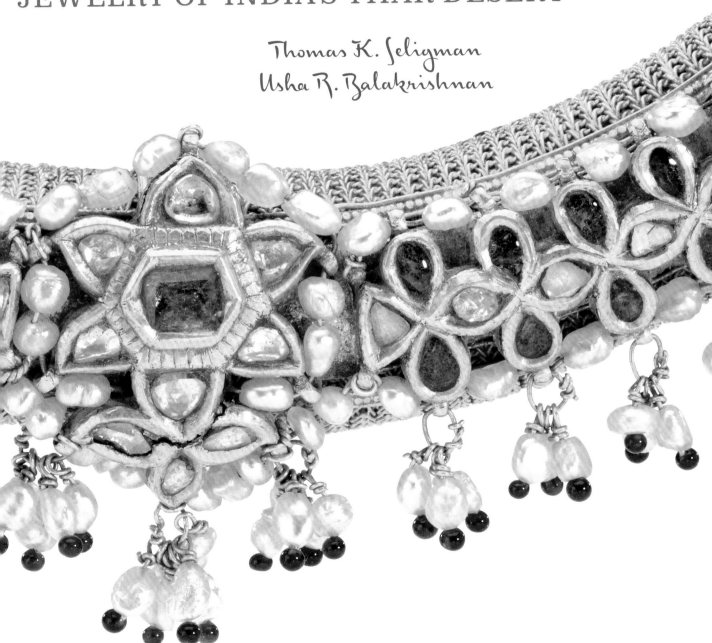

CONTENTS

Foreword
7

Acknowledgments
12

1. From Metal to Ornament: The Language of Jewelry
Usha R. Balakrishnan
17

2. Four *Sonis* from Jaisalmer
Thomas K. Seligman
43

3. Pure Serendipity: An Odyssey into the World of Indian Jewelry
Usha R. Balakrishnan
79

4. Selections from the Ronald and Maxine Linde Collection
of Jewelry and Ritual Arts of India
101

Appendix: A Sonar Origin Story and Two Stories of Gold and Greed
Thomas K. Seligman
131

Bibliography
132

Contributors
133

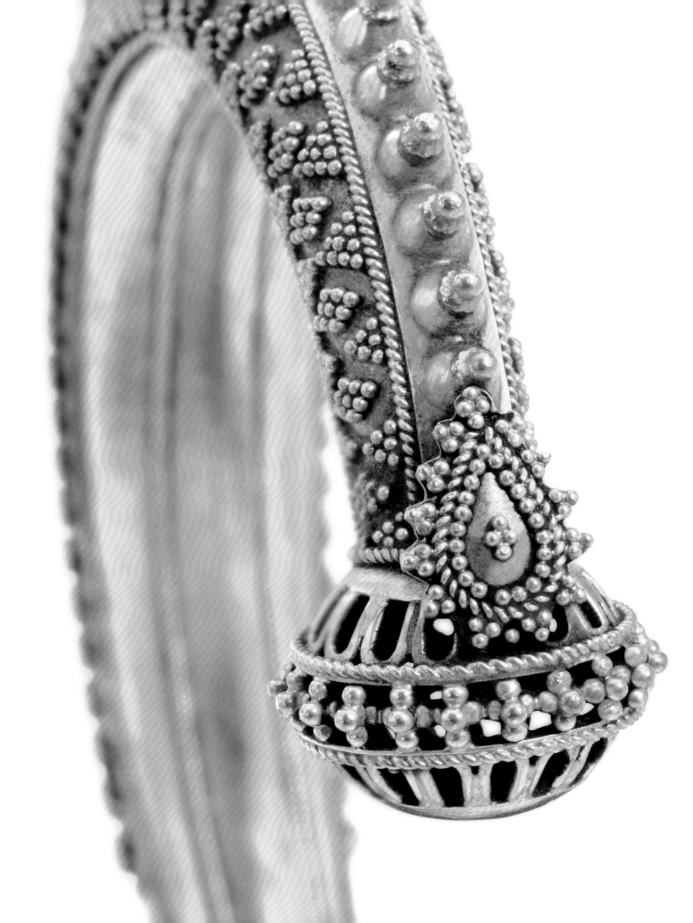

FOREWORD

ENDURING SPLENDOR: JEWELRY OF INDIA'S THAR DESERT takes the Fowler Museum to yet another global locale where the creation of jewelry has achieved remarkable heights as an art form and as an expression of status and identity. In emphasizing silver jewelry produced for rural communities in the far western states of Rajasthan and Gujarat, this project also shifts the focus away from the spectacular and frequently exhibited jewelry designs in gold and gemstones produced primarily for the Indian elite.

The Museum's interest in global silver traditions is long-standing, as the permanent exhibition *Reflecting Culture: The Francis E. Fowler, Jr. Silver Collection* attests. This excellent collection features sixteenth- to nineteenth-century European and American decorative art objects made of silver and other precious metals. In 2008–2009 the Museum examined the emergence of Taxco as a major center of silver design, production, and distribution from the 1930s to the 1970s. *Silver Seduction: The Art of Mexican Modernist Antonio Pineda* focused on the work of one exceptionally talented silver designer who deserved special recognition for the creativity, innovation, and subtlety of his designs; the exquisite incorporation of gemstones; and his virtuoso engineering skills.

The Fowler has also considered the transformation of silver into jewelry in an African context where it is closely associated with the seminomadic Tuareg peoples of the Sahara. The Tuareg are renowned for their distinctive silver jewelry, made by a class of smiths called *inaden*. Thomas Seligman, who had conducted research on the Tuareg for years, focused his work in part on the accomplished smith Saidi Oumba. He considered as well the changes that had occurred in response to the interests of an outside market in Tuareg jewelry and the press of modernity on tradition. Tom eventually asked if the Fowler would partner with the Cantor Arts Center at Stanford University, where he was then director, on developing the major traveling exhibition *Art of Being Tuareg: Sahara Nomads in a Modern World*, which opened at the Fowler in 2006. He also assembled a collection of Tuareg jewelry for the Fowler's permanent collection.

When in 2009 Tom turned his attention to another desert region, the Thar of India, he intended to investigate origin stories among the Soni caste of artisan-jewelers. When he inquired whether the Fowler might be interested in having him gather a modest collection of mostly contemporary Indian jewelry from Jaisalmer, we knew immediately that this would complement the Fowler's extensive and well-documented holdings of textiles and dress from the Kutch region of Gujarat.

As Tom's research progressed, he proposed we collaborate again on another exhibition that would feature for the first time the names, faces, and stories of several individual *sonis* from Jaisalmer. This emphasis on the makers, who typically do not sign their work, would allow us to highlight their distinctive identities and talents. Some of the most spectacular jewelry in the world has been produced by artists from these specialist families, whose tremendous skill had given them only local renown. *Enduring Splendor* celebrates four such families who maintain ateliers in Jaisalmer today. These artists have mastered various techniques necessary to work different metals into the jewelry that traditionally adorns the women of western India from head to toe. Tom's illuminating essay in this volume features photographs and biographies of four *soni* families, each taking a different approach to production and sales. The lead smiths in each family are devoted to tradition yet continuously experiment with design and materials.

Given that Tom's primary research interest is the contemporary *sonis* of Jaisalmer, he suggested we invite the highly respected Mumbai-based Indian jewelry scholar Usha Balakrishnan to participate in the project as a co-curator and author. Her two essays in this volume reveal the depth of her knowledge about the history of ornament and its complex political, social, cultural, and religious roles across the Indian Subcontinent. Her familiarity with myriad forms of adornment—ranging from elite jewelry worked in gold and inset with gemstones and pearls to the dizzying variety of village-based silver jewelry—has strengthened this project and recalibrated our ambitions for it. Her words, like Tom's, reveal profound respect and admiration for India's *sonis* of yesterday and today, and we are indebted to them both for their insightful research and commitment to this project.

In her introductory chapter, Usha traces the earliest evidence of adornment from archaeological records that confirm the presence of jewelry in the Indus Valley for over five thousand years. Given the focus on the Thar Desert region, Usha emphasizes Rajasthan and its enduring jewelry traditions and their symbolism. Mughal emperors and empresses bedecked themselves in jewels to underscore their wealth and status, but as Usha reminds us, the metals and gemstones they wore were believed to possess metaphysical and healing properties. The active role that such spectacular adornment played in people's lives is likely a key to its longevity and importance.

In the course of planning the exhibition, it became clear that we would need to borrow examples of Indian jewelry to supplement the Fowler's own modest collection and to contextualize the new works

Tom had commissioned or purchased from the *sonis* in Jaisalmer. During his museum research in Europe, Tom had learned about an important private collection in the United States belonging to Ronald and Maxine Linde. The collection is unique in focusing not only on high-status examples but also on the breadth and diversity of Indian silverwork. The Lindes graciously showed their extensive collection to Tom and then again to both of us during a second visit. To say that we were amazed by their holdings is an understatement, but we were just as impressed by their knowledge of and commitment to the many talented artists who had produced the works in their collection. The Lindes agreed to lend to the Fowler's exhibition, and Usha, who was very familiar with their collection, helped us make appropriate selections for the exhibition and to incorporate these examples in this book.

The same dose of serendipity that had launched Ronald and Maxine's journey of collecting Indian jewelry and ritual arts in 1990 (which Usha recounts in her second essay in this volume), also played a role in the decision the Lindes recently made to promise their collection to UCLA to be housed with the Fowler Museum. Meeting Ron and Maxine in the context of *Enduring Splendor* led us to discover the many points of convergence between the Fowler's mission as a global arts museum dedicated to the understanding and appreciation of the diverse peoples, cultures, and religions of the world and the Lindes' own commitment to building collections of world arts with the intention of making them available for education and research. As our relationship grew and deepened, we imagined together the potential for their collection of Indian jewelry to complement and enrich a university Museum with major holdings in related areas and activities built around dynamic exhibitions, publications, and public programs informed by interdisciplinary approaches and the perspectives of the cultures represented. I am personally indebted to the Lindes not only for their stunning generosity but also for having the passion, discernment, and tenacity to build, in Usha's words, "an encyclopedic compendium of Indian jewelry." Its vast depth and comprehensiveness will afford unlimited opportunities for teaching and learning about one of India's great artistic legacies. *Enduring Splendor* affords us the first major chance to do so, and we are thrilled that this volume and the exhibition accompanying it allow us to preview highlights from the Ronald and Maxine Linde Collection of Jewelry and Ritual Arts of India, part of a promised gift to UCLA.

We are also grateful to the Los Angeles County Museum of Art (LACMA), the J. Paul Getty Museum, the City Palace, Jaipur, and the National Museum, New Delhi, for their loans of objects and image files.

Special thanks to Bindu Gude, Associate Curator, South and Southeast Asian Art, LACMA, for facilitating our research and loans. I join Usha in thanking both Princess Diya Kumari and Giles Tillotson at the City Palace and Vasundhra Sangwan at the National Museum, India. Warm thanks also go to Leila Kelly, collections manager of the Linde Collection, for providing the detailed lists and documentation that has been invaluable to the curatorial process.

Enduring Splendor has been made possible with a generous gift from C. Diane Christensen, who has supported the Fowler Museum handsomely over the years. I am thankful for her enthusiasm and engagement in this effort, and her strong faith in Thomas Seligman for his role in initiating and nurturing this innovative effort to honor India's *sonis*. Support for this publication has also come from The Ahmanson Foundation, on the recommendation of Foundation Trustee Emeritus, Lloyd E. Cotsen. We also are grateful to an anonymous donor and Avrum and Martha Bluming for their assistance with the project.

The entire Fowler Museum staff is to be recognized for its contributions to the successful realization of this project. As always, staff members have applied their well-honed talents and resourcefulness in managing the details of organizing the exhibition and presenting it so gorgeously in our gallery. The publications team is also to be commended for this beautiful volume designed to reflect the splendor of the jewelry and the talents of the artists who have produced it. I thank Lynne Kostman for her superb and meticulous editing, Gassia Armenian for ably securing reproduction permissions, Don Cole for his gorgeous photography, and Danny Brauer for his elegant design.

Final thanks go to the *sonis* of Rajasthan and Gujarat for long producing objects of great beauty and magnificence, worthy of maharajas, maharanis, and Hindu deities, as well as ordinary women and men living in villages across the Thar Desert. Still working today in Jaisalmer, we salute the jewelers Bhagwan Das Soni, Dharmendra Soni, Hanuman Soni, and Roopkishor Soni, who continue to adorn their rural and urban Indian clients as well as those of us who seek their wares as tourists and customers from afar. The Fowler is proud to share their stories as well as their unbounded creativity.

Marla C. Berns

SHIRLEY & RALPH SHAPIRO DIRECTOR

ACKNOWLEDGMENTS

IN THE COURSE OF MY STUDY of the *sonis* of the Thar Desert region, I have received help and guidance from colleagues, new acquaintances, and myriad scholars and practitioners living and working in India. I would like to express my profound gratitude to those who have generously shared their time, wisdom, knowledge, and insights, most especially: Anita Awasthy, Ritu Raj, Jagdish Saxena, Raja Syed Muzaffar and Meera Ali, Rajiv Arora and Rajesh Ajmera of Amrapali Jewels, Mahendra Singh, Dipak and Usha Shah, Sarwar Kahn, Virendra Singh Bhati, Kojraj Borawat, Ganpat Bhargve, Vikram Singh, Kuldeep Kothari, Deen Dayal Ojha, Mohanlal Bissa, and N. K. Sharma.

In Jaisalmer I especially want to thank and to sing the praises of Jitendra (Jitu) Kumar Bissa and his family for their support, companionship, and friendship. Om Prakash Kewaliya (Fifu) and his family have also provided friendship, lodging, great food, and company, as well as access to many *sonis* and other knowledgeable people in Jaisalmer who have helped to shape this project. Fifu has, in addition, helped with photography, translation, and interpretation. He has become a dear friend, and I can't thank him enough.

Many *sonis* allowed me to visit their workshops and provided important information and insights, including Mahesh Soni, Devilal Laycha Soni, Mukesh Amratlal Pomal Soni, Jay Pomal Soni, Pravinbai Soni, Amrutlal Solanki Soni, Khimabhai aka Bhogilal Hansaraj Katta Soni, Bhogilal Katta Soni, Damodarlal Babeary Soni, Raja Soni, Inderlal Dadolia Soni, Narayan Das Soni, Pukhraz Soni, and Shantilal Tulsidas Soni. This volume focuses specifically on four *sonis* and their families, and I want to express thanks for their generosity and help with both the publication and the exhibition. My sincere appreciation goes to Govindlal, Bhagwan Das (B. D.), and Ram Soni; Dharmendra and Om Soni; Hanuman Soni and his sons, Jasraj, Jeetu and Raju Soni; and Roopkishor Soni and his many brothers.

Scholars and curators from many museums in India, Europe, and America shared objects in their collections with me and gave me access to collection data and files. I would especially like to thank Nick Barnard of the Victoria and Albert Museum and the late Waltraud Ganguly. Dr. Judy Frater, an independent scholar of Indian textiles and dress who has lived in India for over two decades, provided invaluable friendship and advice while I was researching *sonis* in Gujarat.

My colleague and co-curator Usha Balakrishnan has been a pleasure to work with and has contributed immensely to the realization of this book and the exhibition. Her vast knowledge of Indian jewelry and dress and her extensive experience in museum collections have contributed greatly to the project, as has her engaging and lucid writing. She has become a dear friend, and I thank her so much for everything.

Projects of this scale require support of many kinds, and I owe a debt of gratitude to C. Diane Christensen who provided key resources early in the project that enabled it to reach fruition. Dean Richard Saller of Stanford University also graciously allowed me the time and support to conduct much of my fieldwork in India. Thanks also must go to the lenders to the exhibition, the Los Angeles County Museum of Art, the J. Paul Getty Museum, and especially Ron and Maxine Linde who shared their vast collection and knowledge, which have significantly enhanced the project. My thanks and appreciation also go to my colleague and friend Marla Berns, who has championed the project from the very beginning. I am grateful to Marla and to her fine staff at the Fowler Museum.

My wife and best friend, Rita Barela, has traveled with me on each and every field trip to the Thar. She has spent hours in museum storage rooms and galleries and has sat on the floors of more *soni* workshops than can be counted. Her love of jewelry and her keen insights into people have been invaluable to my understanding of the *sonis*. She has also provided valuable commentary on various drafts of my essay and made helpful suggestions about shaping the exhibition. To her and to my family, I am forever grateful.

Thomas K. Seligman

CREDIT FOR THE INSPIRATION for this project must go to my colleague and co-curator, Tom Seligman, and I am indebted to him for inviting me to be a part of it. My own interest in and fascination with Indian jewelry goes far beyond the immediacy of form, design, and material, and our exploration of the *sonis* of the Thar region has opened a new window onto this field. For the first time ever, the genius, skill, and labor that goes into the crafting of each and every earring, bracelet, and necklace have been foregrounded. In Jaisalmer we were able to spend hours in the ateliers of Bhagwan Das, Dharmendra, Hanuman, and Roopkishor Soni, talking to them about their lives and observing them as they worked transforming metal into ornament. I thank Tom for telling their life stories in such detail, as well as for the enduring friendship that my husband and I have formed with Tom and his wife, Rita.

To Bhagwan Das, Dharmendra, Hanuman, and Roopkishor Soni, I bow my head with respect for keeping alive the skills of the hand-craftsman that set Indian jewelry apart. They invited me into their homes, served me sumptuous meals, shared their hopes and aspirations, and drew me into the magical circle of creation. I am grateful to them

and their families for their hospitality, for their generosity, and for keeping the tradition alive as they train their sons to assume the *soni* mantle. I also thank Fifu in Jaisalmer, who welcomed me into his elegant boutique hotel and made me a part of the family. From his terrace we looked out every night at the ethereal beauty of the Jaisalmer Fort, rising like a golden colossus from the desert sands, as we discussed the project, examined silver jewelry, and shared our thoughts.

To Ron and Maxine Linde, I am forever grateful for their friendship and generosity, and for their recognition of the beauty of silver and the exceptional jewelry forms worn by the ordinary women and men that are showcased in this book and exhibition. I owe special thanks to Leila Kelly, the registrar of the Linde collection, whose speed and efficiency were truly amazing. Many thanks to the Lindes and to all the lenders to the exhibition—their loans allow us to tell the story of Indian jewelry and place the items in context.

In India, I acknowledge the invaluable assistance and cooperation of Princess Diya Kumari, Secretary and Trustee, and Giles Tillotson, Consultant Director (Research, Publications and Exhibitions), at the Maharaja Sawai Man Singh II Museum, City Palace, Jaipur for permission to reproduce rare photographs of the bejeweled royal *pardayat* (zenana) women in the exhibition. My sincere thanks also to Vasundhra Sangwan, Outreach Officer, National Museum, New Delhi, for so kindly facilitating the reproduction of the bead necklace from the Indus Valley that is featured in the present volume.

I also extend my gratitude to Babubhai Soni, a goldsmith turned retailer in Mumbai who migrated to the city from Kutch, Gujarat, more than sixty-five years ago. Now, well into his eighties, Babubhai is still an active and respected member of the jewelers' community. I spent many hours with him discussing the history of the community and learning about the complex social and caste structures of *sonis* in different parts of India.

Above all, my overwhelming love and thanks are due to my husband, Bala, and son, Aryadita, for their unflagging support, constant encouragement, and for always indulging me in my jewelry adventures. They share my interest, my curiosity, and passion for this subject. To them, I am forever grateful.

To Marla Berns for her vision in supporting this project and to her colleagues at the Fowler Museum at UCLA, I offer my special thanks for bridging the nine thousand miles that separate Mumbai and Los Angeles—we are now bound by threads of gold and silver.

Usha R. Balakrishnan

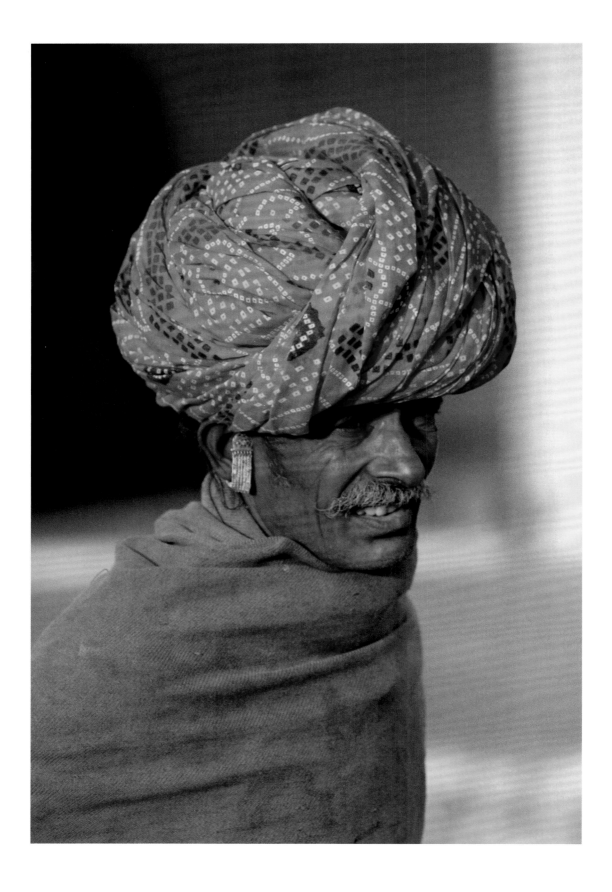

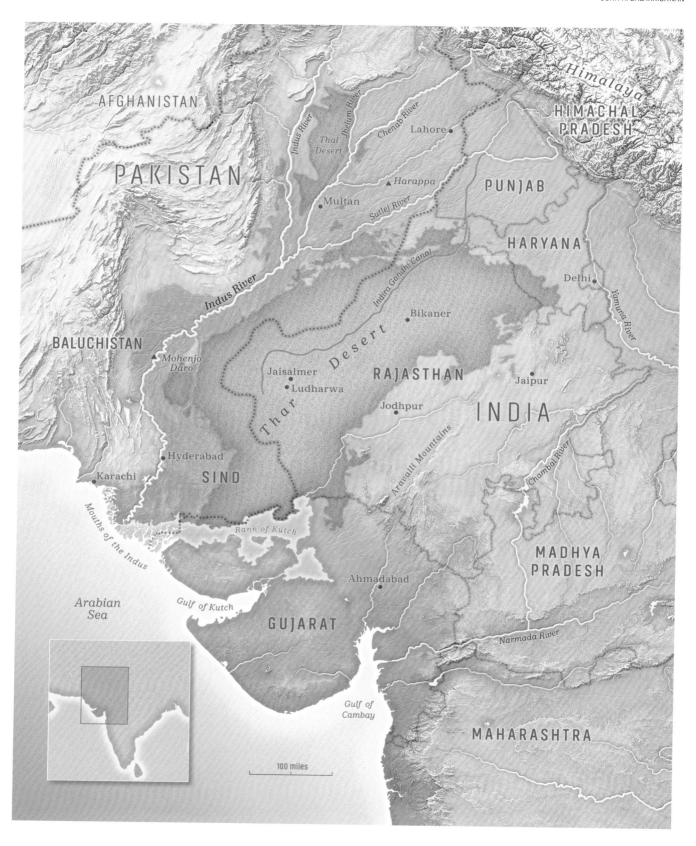

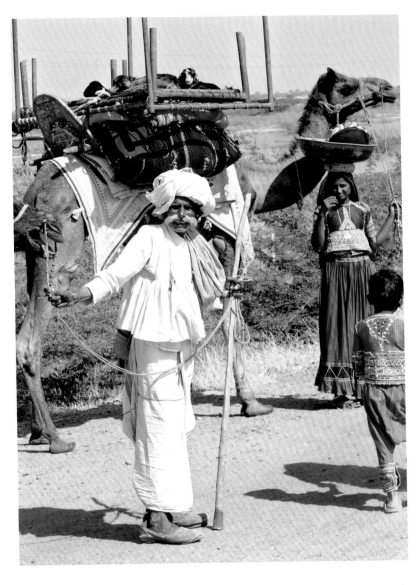

1.3 A nomadic Rabari herdsman and his family members appear with all their worldly belongings loaded on the back of a camel.
PHOTOGRAPH BY THOMAS K. SELIGMAN, NORTHERN GUJARAT, 2010.

1.2 Rajasthan is located on the western periphery of India.

on the region. During Mughal rule from the sixteenth to the nineteenth century, the trade routes from Delhi and Agra to the flourishing ports of Gujarat and western India passed through Rajasthan. Within this region, Jaisalmer, an oasis in the Thar, was a caravan stop on the ancient trade route between Africa, Persia and the Arab world, and the vast Gangetic plains of India.

From Afghanistan, Sind, and Baluchistan, nomadic tribes traveled into Rajasthan (fig. 1.3), bartering, trading, breeding camels, and seeking pastures for their cattle before finally settling down as pastoral nomads. The warrior Bhils and Gujjars (fig. 1.1), the camel-breeding Rabaris, the Jats, Meenas, Banjaras, Meghwal, and Kalbelias all made the region their home. Rajasthan was the land of the warrior Rajputs (sons of kings) and home to the richest princely states of India. Maharajas (fig. 1.4) and feudal *thakurs* (landlords) waged wars, amassed land, and accumulated extraordinary wealth.

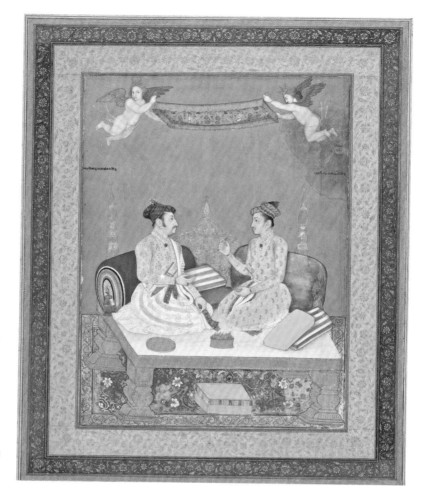

1.4
Maharaja Jai Singh of Amber and Maharaja Gaj Singh of Marwar, Folio from the Amber Album
Attributed to Bichitr (India, active circa 1610–circa 1650)
India, Mughal Empire, circa 1630
Opaque watercolor, gold, gesso, and ink on paper
Image: 25.08 x 18.42 cm; sheet: 45.09 x 34.29 cm

LOS ANGELES COUNTY MUSEUM OF ART, FROM THE NASLI AND ALICE HEERAMANECK COLLECTION, MUSEUM ASSOCIATES PURCHASE, M.80.6.6

The two maharajas sit together on a throne of gold, and each wears an elaborate array of jewelry.

The jewelry featured in this volume and in the exhibition it accompanies is primarily from Rajasthan and Gujarat, and the core pieces were manufactured by jewelers (*sonis* or *sonars*) in Jaisalmer—the westernmost metropolis of India, a mere 43 miles from the Pakistan border. Less than 175 miles west of Jaisalmer, on the southern plains of the Indus River, are the ruins of the ancient city of Mohenjo Daro. It is in this city that the history of India, and with it the history of Indian jewelry, began. Mohenjo Daro and Harappa, located about 350 miles to the north,[5] were thriving cities within an extremely advanced civilization that flourished between 3500 and 1700 BCE.

While the writings engraved on hundreds of seals from these cities remain undeciphered, the cultural character of the civilization that produced them is manifest in its material remains. Statues, pottery, and the beautifully made steatite seals themselves reveal a high degree of artistry. Fillets, necklaces, bangles, and earplugs crafted from sheet gold; ornaments of shell and ivory; beaded necklaces of gold and silver; and beads of carnelian, lapis lazuli, and glazed faience (fig. 1.5)—all demonstrate technical knowledge of jewelry manufacture and the complex processes for the production of beads, including sawing, shaping, boring, and polishing.[6]

According to archaeologist Mark Kenoyer, "it was during this time that the rules defining civic order and interaction were being refined and codified."[7] Based on a study of the shapes, sizes, and raw materials of bangles and beads excavated from the Indus sites, he notes "ornament styles represent a highly efficient form of visual communication and public identification."[8] They functioned as symbols of rank and position in the social order and as articles of faith, and they were worn "to avoid conflict and confrontation between socially stratified and ethnically diverse populations."[9] In the five thousand years between the heyday of the Indus Valley civilization and the present, jewelry making and the many reasons for wearing jewelry have endured and evolved.

There are nonetheless large gaps in the chronological history of Indian jewelry due to the lack of surviving examples. There are numerous reasons for this. In the Hindu tradition, for example, the dead were cremated, and jewelry was recycled within the family after a death, making it more subject to loss and deterioration over time than if it had been preserved in a burial site. Furthermore, the Indian Subcontinent is vast with varied geographical regions inhabited by peoples who speak different languages, wear different styles of clothing, and practice different dietary habits. There are Hindus, Buddhists, Jains, Muslims, Christians, and countless tribal groups who follow a gamut of religious ideologies and beliefs. Every region developed its own design sensibility and ornament forms. Moreover, due to the constant migration of communities within the country, jewelry designs appear similar in regions as far apart as Rajasthan and Bengal or Punjab and Kerala.

In western India, the movement of nomadic tribes and transhumance extended across the contiguous regions of Afghanistan, Sind, and Baluchistan, and of Rajasthan, Gujarat, and Madhya Pradesh, with a consequent transferring of shapes and designs, as well as materials and techniques. The diversity of forms, the variations of designs, and the vast quantities of jewelry that were commissioned and worn—crafted by largely illiterate, relatively poor, and seemingly unsophisticated communities around India—are without parallel. Given this extremely complex scenario, this book and the accompanying exhibition undertake a historical approach that folklorist Pravina Shukla has described as "the methodical documentation of the present in order to capture complete one moment in time."[10]

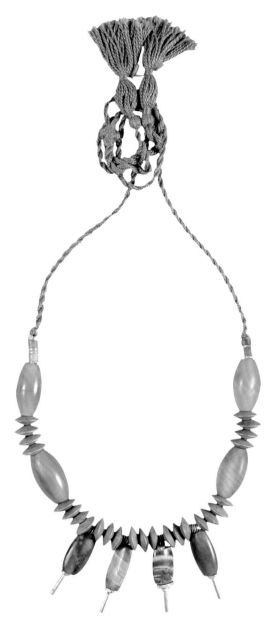

1.5
Necklace
Mohenjo Daro, circa 2600–1900 BCE
Gold, jade, agate, jasper
NATIONAL MUSEUM, NEW DELHI, ACC. NO. 49.244-105
NOT IN EXHIBITION

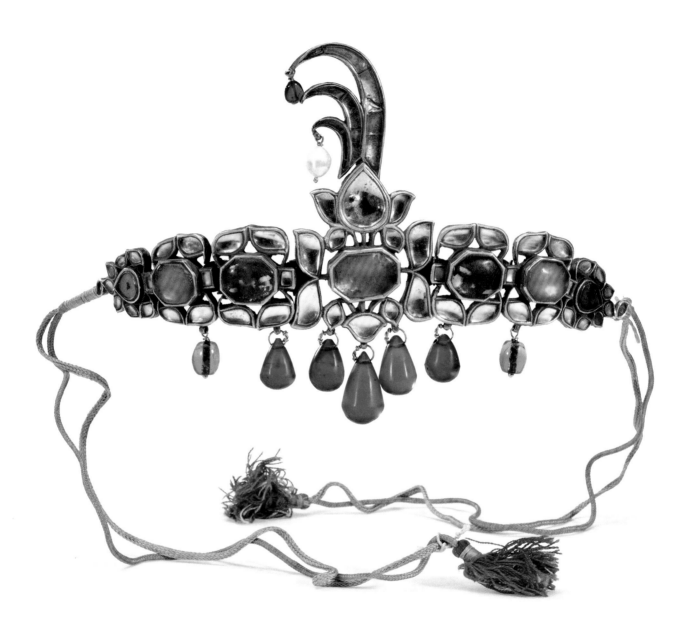

1.6
Turban ornament (*sarpech*)
Rajasthan, seventeenth century
Gilt silver, glass
10.2 x 17.8 cm

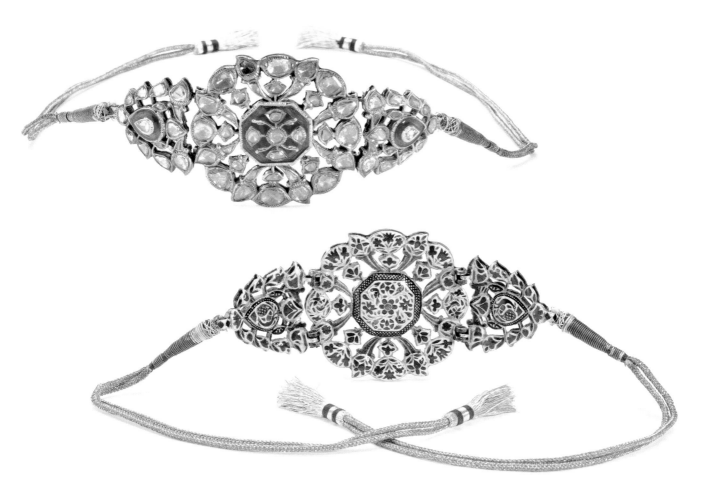

1.7a,b
Front (top) and back (bottom) of
an armband (*bazuband*)
Jaipur, Rajasthan, early nineteenth
 century
Gold, diamonds, rubies, enamel
7 x 12.4 cm
RONALD AND MAXINE LINDE COLLECTION, PROMISED
GIFT OF RONALD AND MAXINE LINDE, 17004

This study emphasizes the symbiotic relationships that exist between jewelry and society, artist and jewelry, and artist and society. It sets forth the historical and cultural context of ornament forms, materials, and manufacturing techniques, viewed simultaneously from the perspectives of anthropology, history, and art history. The ornaments that form the centerpiece of the exhibition were made by four jewelers (*sonis*) from Jaisalmer: Bhagwan Das, Dharmendra, Hanuman, and Roopkishor (who are interviewed by Thomas Seligman in his essay in this volume). Though recently produced, the pieces conform to the exacting standards of the ancient Indian tradition of jewelry manufacture, and they have been made with tools and techniques that have remained virtually the same over the centuries. They embody what jewelry stands for and what adornment means in the sociocultural milieu of India, as well as the roles jewelry plays in the lives of those who wear it. The ornaments are typical of those worn by the men and women of the tribes and rural communities living in and around Jaisalmer. Hanuman's creations are heavy and elemental, cast and shaped from solid silver and incised and punched with designs (see figs. 2.33–2.35). Dharmendra's jewelry is also traditional

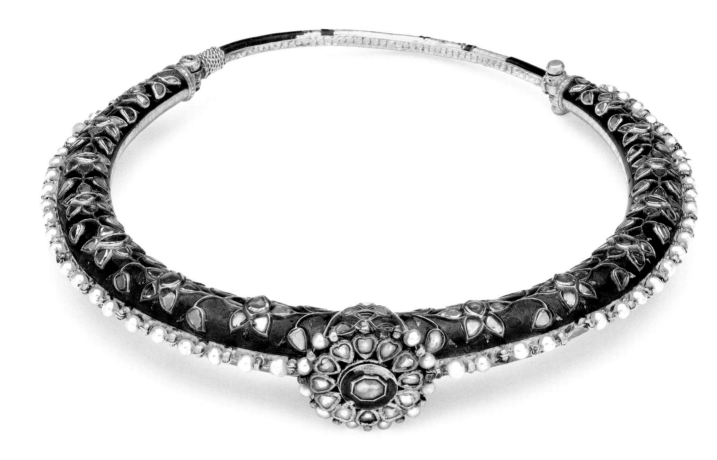

1.8a,b
Front (left) and back (right) of
a necklace (*hasli*)
Bikaner, Rajasthan, eighteenth
century
Gold, diamonds, pearls, enamel
L: 16.5 cm
RONALD AND MAXINE LINDE COLLECTION, PROMISED
GIFT OF RONALD AND MAXINE LINDE, 1139

and fashioned from silver sheet and silver wire (see fig. 2.28). Bhagwan Das's pieces are contemporary interpretations of classical designs, but covered with a gold wash, they have immediately been elevated to the realm of the elite (see fig. 2.12). Completely departing from tradition, the bracelet, pendant, and ring (see figs. 2.47, 2.52, 2.54) made by Roopkishor appear minuscule and whimsical, but their masterly workmanship and minute detailing are in accordance with "the *dharma* [duty] of his caste."[11]

The long-standing jewelry manufacturing tradition of Rajasthan is embodied in some of the most fabulous pieces of royal jewelry to have survived (fig. 1.6). These are made of gold and set with gemstones, and they are now scattered in museums and private collections around the world. Gold jewelry is delicate, and small amounts of the metal were beaten into thin sheets and fashioned into large and incredibly intricate pieces. The rarity and high price of gold required that innovative crafting techniques be introduced. *Kundan*, a technique whereby narrow ribbons of pure gold are compressed around a gem to hold it in place without the application of heat, is Rajasthan's legacy to the art of jewelry (fig. 1.7a,b).

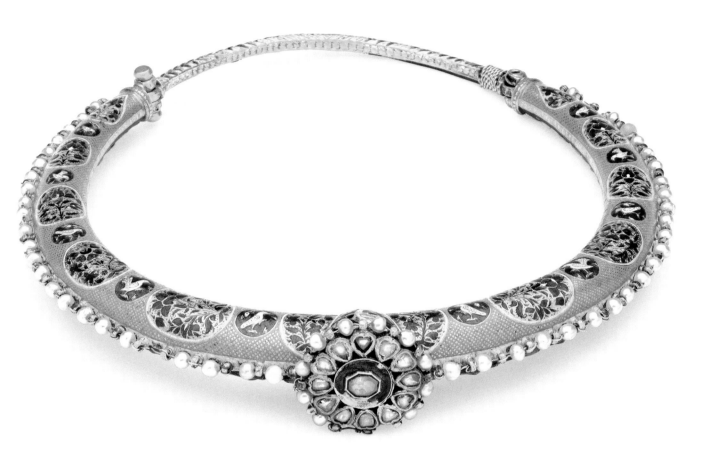

In Jaipur, about 300 miles to the east of Jaisalmer, the Kachhawaha maharaja Jai Singh II designed a royal capital in the early eighteenth century. Given its close proximity to the Mughal court in Delhi, Jai Singh was able to invite artists, poets, musicians, craftsmen, and goldsmiths to live and work in his city and made it the archetype of the history, culture, and power of the Rajputs. It was also in the ateliers of Jaipur that *minakari*, the art of enameling the reverse side of necklaces, armbands, bangles, and other ornaments with vitreous glass paste—in order to protect the delicate gold from wearing away with constant use—was taken to unprecedented heights in the eighteenth and nineteenth centuries (fig. 1.8a,b, see fig. 1.7a,b).

Silver had its own unique idiom and manufacturing methods as well. Silver jewelry was large, solid, and organic, and because it was cheaper and more abundant than gold, jewelers had fewer compunctions about working with it. Large quantities of silver were mined in the Aravalli Mountains,[12] and silver currency flowed into India to buy the luxury commodities, such as diamonds, pepper, and cotton cloth, that were so avidly sought after in other parts of the world. Farmers also received payment for their cattle and produce in silver coins.

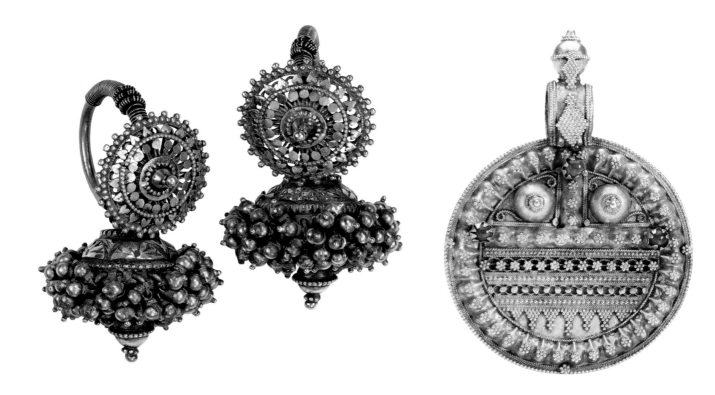

1.9
Earrings (*durgla ihumar*)
Rajasthan, early twentieth century
Silver
L (earring a): 8.4 cm; (earring b):
 8.3 cm
RONALD AND MAXINE LINDE COLLECTION, PROMISED
GIFT OF RONALD AND MAXINE LINDE, 12893A,B

1.10
Amulet pendant (*jibi*)
Gujarat, circa nineteenth to early
 twentieth century
Gold, spinels
8 x 8.3 cm
RONALD AND MAXINE LINDE COLLECTION, PROMISED
GIFT OF RONALD AND MAXINE LINDE, 11113

The term for silver is *chandi* from *chand* meaning "moon," which played a very important role in the life of nomads who traveled by its light and were guided by the stars as they crossed the desert at night. Silver was also associated with water, a precious and scarce commodity. Gold and silver are the quintessential metals of Indian jewelry. Both were prized for their intrinsic value, coveted for their luminosity, and revered for their ritual purity. Gold, a symbol of the sun, was the prerogative of the upper castes and the affluent, while silver was an emblem of pastoral and tribal cultural identity.

In the palaces of maharajas, mansions of wealthy merchants, huts of rural communities, and even among pastoral nomads, adornment started at birth and was regulated by prescribed norms and the wearing of specific ornament forms. It continued to be an essential component of attire and ritual throughout life. A newborn baby was adorned with a bracelet of black beads, which symbolized the pupil of the eye wherein resided the evil gaze, and it served to ward off potential dangers. Gold and silver bangles placed on the baby harnessed the energies of the sun, and anklets with tiny bells alerted the mother to her child's activity and well-being. The ears of young girls and boys were pierced to activate and absorb the powerful energies of the sun and ensure physical health. Simple earrings were replaced with larger and more seductive ear ornaments (fig. 1.9) as a young girl approached marriageable age. Her nose was pierced to enhance her fertility, and charms were suspended around her neck to attract good luck (fig. 1.10).

When it came to buying jewelry for an important life event such as marriage, the choice was always traditional, defined by religion, region, and caste. Gujjar girls, for example, usually received a suite of jewelry from their own family that included a head ornament, large earrings, a necklace strung with floral elements worn high around the neck, *hasli* (a torque necklace; see fig. 2.33), *nimboli* (another type of necklace; see fig. 2.23), and a set of bangles. Anklets were given to the bride-to-be by the family of her future husband, and they symbolized the fettering of the girl to her new relatives (see fig. 4.40). On her wedding day, adorned with all this jewelry, the bride was not only beautiful but also, and more importantly, showcased the prosperity of her father. The jewelry served as her personal wealth (*stridhan*).

Traditionally, a woman did not inherit her husband's property, and her security reposed in the gold and silver that she brought with her at the time of her marriage. Her marital status was communicated by the marriage necklace (*mangalsutra*), which she would henceforth wear at all times, and by toe rings (see fig. 4.42) and nose ornaments (see fig. 4.12) that activated energies to facilitate childbearing and give her composure and equanimity in her relationships with her husband, children, and family. The *hasli* made by Hanuman (see fig. 2.33), for example, was put around the neck of a girl when her marriage was fixed to signify that she was betrothed (fig. 1.11). According to Hanuman, this type of torque necklace, which is very heavy and hard to remove, is a metaphor for the commitment and binding nature of the engagement, and he matter-of-factly related to me that "only if [the bride's] head is cut off can the *hasli* be taken off."[13] The stiff torque was thus worn after marriage too, its heavy weight pressing down on the collarbone and the cuboid centerpiece gently stimulating vital energy points in the base of the neck in the vicinity of the thyroid gland, improving circulation and healing thyroid conditions.

After marriage, the husband regularly purchased jewelry to serve as a depository for his personal wealth. These items could eventually be pledged as collateral for loans, sold in times of need, or melted and recycled into new ornaments. Because of its intrinsic value, jewelry served as a bulwark against financial instability. To the rural population especially, who depended on agriculture and the annual monsoon

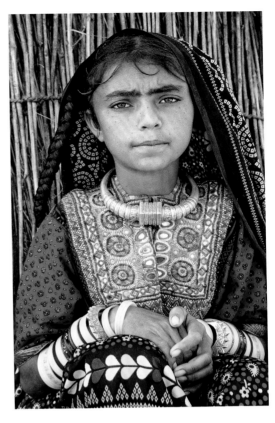

1.11 This young married girl from the nomadic Fakirani Jat tribe wears a type of torque known as *hasli* around her neck.
PHOTOGRAPH BY KIMBERLEY COOLE, CHHADVARA VILLAGE, KUTCH. GETTY IMAGES #455671751.

1.12
Amulet pendant (*patri*)
Gujarat or Rajasthan, late nineteenth to early twentieth century
Silver
5.7 x 4.5 cm
RONALD AND MAXINE LINDE COLLECTION, PROMISED GIFT OF RONALD AND MAXINE LINDE, 15768

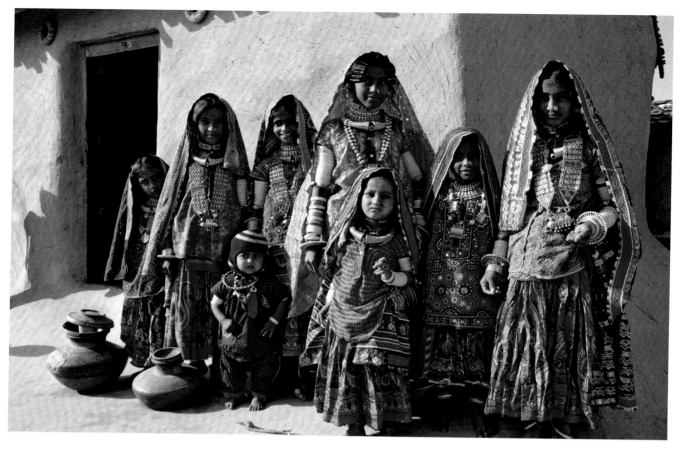

1.13 A group of young village girls in Gujarat wear jewelry that compliments their beautifully embroidered skirts and blouses.
PHOTOGRAPH BY ROBERT HARDING/ALAMY, B5A36K.

for survival, jewelry served as a form of insurance. A good monsoon resulted in a good harvest, and the profits were invested in gold and silver jewelry. If the rains played truant, the *soni* served as a moneylender, and the same jewelry was pawned for cash to tide the family over during the bad times.

Dress, fabric, and jewelry, therefore, play a significant role in the identity of a Rajasthani. A Rajasthani man attired in a pure white *dhoti* (lower garment) and *kurta* (tunic) with a flaming red *safa* (turban) wrapped around his head is a familiar sight in Jaisalmer (see fig. 1.1). The presence of wide gold bands (*shankli*) draped around his ears will reveal that he is a Gujjar or Banjara.[14] If the ornament is a horseshoe-shaped *bawaria* and worn only in the helix of the left ear, he is a Chowdhury Jat.[15] Images of the deities Kali, Durga, the Sapta Matrikas, Bhairava, or Hanuman die-stamped on silver plaques and strung with a black cord around his neck indicate his family deity (fig. 1.12).

A woman's cultural identity is constructed by the style of her clothes, the beautiful embroidery that appears on them, and her jewelry. Women wear vibrantly colored skirts with blouses that are embroidered with tiny mirrors and motifs and patterns that are distinct to tribe and religion (fig. 1.13). The jewelry a woman wears also conveys its own identity. Without a formal introduction or even a word being spoken,[16] the social, religious, and communal affiliations

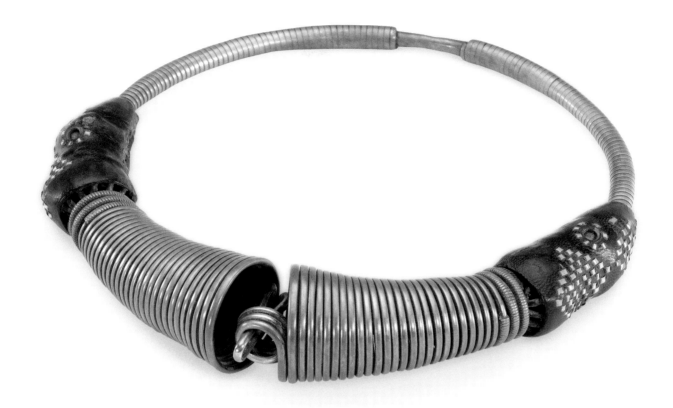

of the woman are instantly broadcast. A twisted wire torque (*vadlo*; figs. 1.14, 1.15) around her neck would declare that she was a Rabari; the rigid torque (*hasli*) with the rectangular, cuboid shape in the middle instantly identifies her as a Muslim Fakirani Jat of the Thar (see fig. 1.11); and if she were wearing a gold *nimboli*, she would be a married Hindu girl from a well-to-do family (fig. 1.16). These long-standing traditions wherein caste and class affiliations are reflected in specific forms and designs of jewelry still endure in remote places like Jaisalmer, but they are fast disappearing in other more accessible areas in India.

Indian sculptures from antiquity onward testify that while human figures might be devoid of clothing, they are almost never without jewelry. Clay figurines of mother goddesses (fig. 1.17), stone sculptures that decorate the walls of temples (fig. 1.18), and murals painted in vibrant colors—together with the infinitesimally small number of gold and silver items that have been found in the course of excavations—provide a veritable encyclopedia of centuries of jewelry design and reveal the sophistication of metalworking techniques and the range and variety of ornament forms. Furthermore, texts on gemology and statecraft deal with a variety of issues, such as the location of mines and the metaphysical qualities of gemstones. Poetry, literature, treatises on dance and drama, travelogues, court chronicles, and ethnographic studies provide a wealth of information.

1.14
Necklace (*vadlo*)
Guajarat, late nineteenth century
Silver, leather
L: 14 cm
RONALD AND MAXINE LINDE COLLECTION, PROMISED
GIFT OF RONALD AND MAXINE LINDE, 11807

1.15 A Rabari woman wears an impressive *vadlo*, a type of torque, around her neck.
PHOTOGRAPH BY THOMAS K. SELIGMAN, KUTCH, GUJARAT, 2010.

1.16 Adorned in her dowry, a young woman wears a large gold necklace known as a *nimboli*.
PHOTOGRAPH BY THOMAS K. SELIGMAN, JAISALMER, RAJASTHAN, 2009.

To the Mughal emperors, jewelry and gemstones were the ultimate symbol of wealth and power. Emperors Jahangir and Shah Jahan stunned visitors to their courts with the magnificent gems and jewelry they wore on their turbans, around the neck, and on the arms and wrists. In 1617 Sir Thomas Roe, English ambassador to the court of Jahangir, described the emperor as

> clothed or rather loden with diamonds, rubies, pearls, and other precious vanities, so great, so glorious…his head, necke, breast, armes, above the elbowes, at the wrists, his fingers each one with at least two or three rings, fettered with chaines or dyalled [i.e., faceted] diamonds, rubies as great as walnuts (some greater) and pearles such as mine eyes were amazed at."[17]

Roe might have been equally awestruck had he encountered a Rabari belle in Rajasthan dressed in her mirror-studded skirt and adorned with beautiful silver jewelry from head to toe. For Rabari and Meghwal women, ornaments and dress merge and become one with the body. It is rare to see even a very poor person without at least a small piece of jewelry at all times. Young boys and men

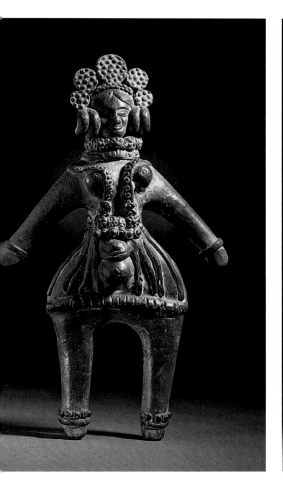

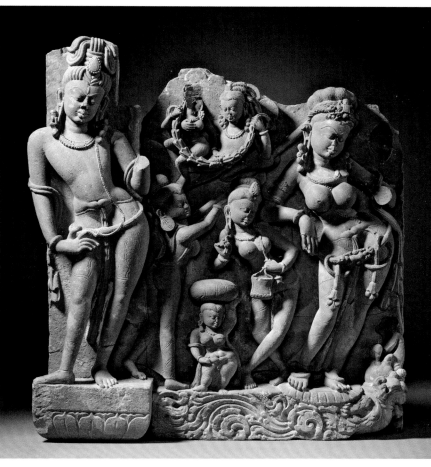

1.17
Goddess
Mathura, Uttar Pradesh, India,
 circa 200 BCE
Terra-cotta
24.13 x 11.75 x 3.81 cm
LOS ANGELES COUNTY MUSEUM OF ART; GIFT OF
MR. AND MRS. SUBHASH KAPOOR, M.85.72.3

This terra-cotta mother goddess
wears elaborate jewelry, including
a large headdress.

also wore and continue to wear jewelry: earrings serve to stimulate
energy points in the ears (figs. 1.19, 1.20); armbands and neck cords
with amulets protect from malevolent spirits; and circlets of silver
and gold are clasped around the wrists and ankles to harness solar
and lunar powers.

The forms of necklaces, earrings, bangles, and even anklets are
many, and every design variation has a unique name. In Rajasthan
head ornaments include the *rakhdi*, a round ornament worn on the
center of the forehead; *sheeshful*, a flower-shaped forehead jewel;
or *borli*, a round jewel worn on the parting of the hair over the fore-
head (fig. 1.21a,b). *Aad, nimboli, kanthi, kanthla, khungali, hasli, hansadi,
mandaliya, timaniya, champakali, panchladi*—all are names for neck
ornaments, which range from wide collars, to stiff torques, and
elaborate necklaces and chains that cascade down the chest (fig. 1.22).

To those conversant with the language and dialects of the
region, the names also provide clues to the tribal affiliation of the
ornament, its purpose, and often the inspirational source for its
design. The *borla* derives its form and name from *bor*, or the Indian
plum, a fruit endowed with powerful medicinal properties; *hasli* is
from *hansuli* meaning "collar bone"; and *champakali* are the buds
of the *Michelia champaca* flower. Importantly, since we are dealing

1.18
The River Goddess Ganga (Ganges)
 and Attendants
Rajasthan, circa 800 CE
Red sandstone
71.43 x 66.04 x 19.05 cm
LOS ANGELES COUNTY MUSEUM OF ART; FROM
THE NASLI AND ALICE HEERAMANECK COLLECTION,
MUSEUM ASSOCIATES PURCHASE, M.79.9.10.1

Ganga is the presiding deity of
the River Ganges. She is por-
trayed adorned with elaborate
gem-studded hair jewels, large
earrings suspended from her
extended earlobes, a torque
necklace, armbands, bangles,
anklets, and what appears to be
a thick woven-gold girdle slung
low around her waist.

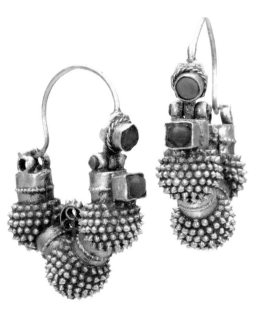

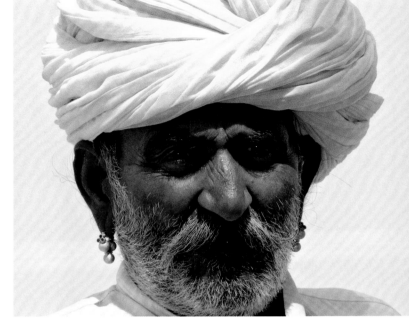

1.19
Earrings (*gokhru*)
Rajasthan, late nineteenth to
 early twentieth century
Gold, turquoise
L (each): 3.1 cm
RONALD AND MAXINE LINDE COLLECTION, PROMISED
GIFT OF RONALD AND MAXINE LINDE, 16161

1.20 A farmer from the Gujjar
community wears a pair of
gokhru earrings.
PHOTOGRAPH BY THOMAS K. SELIGMAN,
PUSHKAR, 2009.

1.21a,b
Front (top) and side (bottom)
view of a head ornament (*borla*)
Udaipur, Rajasthan, circa 1920
Gold, pearls, diamond, enamel
Diam: 4.2. cm
RONALD AND MAXINE LINDE COLLECTION, PROMISED
GIFT OF RONALD AND MAXINE LINDE, 11889

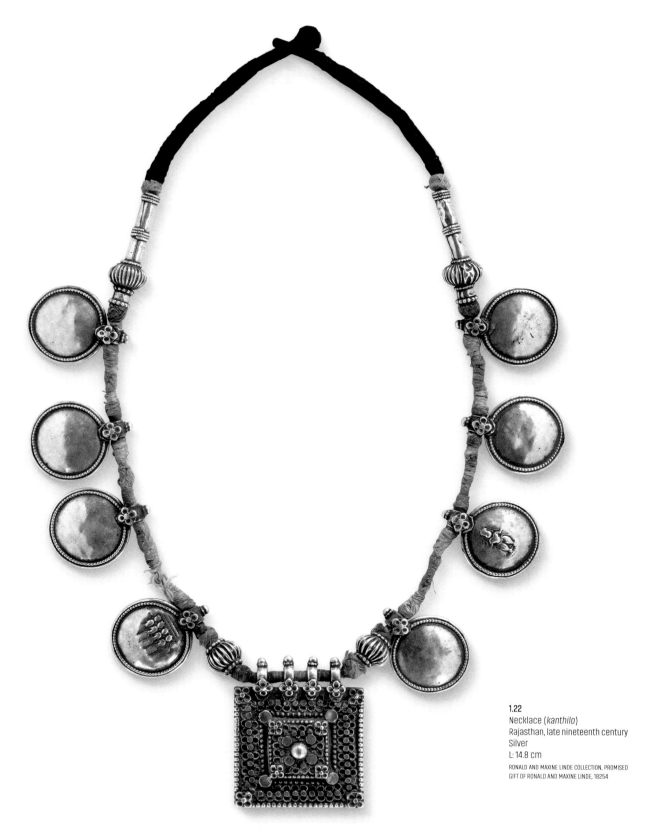

1.22
Necklace (*kanthilo*)
Rajasthan, late nineteenth century
Silver
L: 14.8 cm

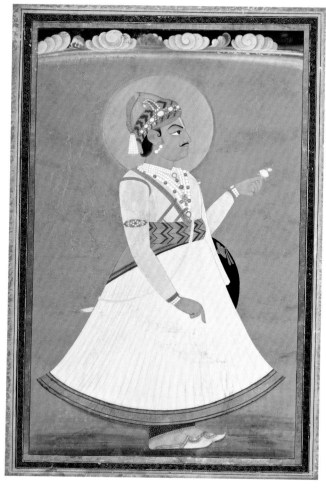

1.23
Maharaja Pratap Singh
(r. 1778–1803)
Jaipur, Rajasthan, circa 1780
Watercolor and gold on paper
Sheet: 55.25 x 38.1 cm; image:
49.21 x 29.21 cm)

LOS ANGELES COUNTY MUSEUM OF ART;
GIFT OF MARILYN WALTER GROUNDS, M.81.272.4

largely with peoples forming "an agricultural society, their thinking is always dominated by the fertility of their land,"[18] and flowers, leaves, fruits, berries, and even thorns are all incarnated as ornaments. The *pahunchi* bracelet with spikes made by Dharmendra (see fig. 2.27) simulates the large thorns that grow in the desert and was worn ostensibly to keep animals at bay. While it is highly unlikely that these spikes could function as an effective weapon, symbolically they provided a notion of protection to the wearer, and, according to Oppi Untracht, they "eventually drifted into women's jewelry and became tools of feminine provocation."[19]

Today, the source of design inspiration and the symbolism of enigmatic ornament forms such as the pyramidal bangle made by Hanuman (see fig. 2.42) are often difficult to decipher or long forgotten. Known as *kangan* or *katria* in Sindi, the unusual projecting centerpiece of the bracelet is a cluster of shapes: a solid hexagon forms the base on which is placed a six-sided pyramid and a cup-like holder surmounted with a solid silver ball. It is worn around the upper arm or on the wrist by women of the Fakirani Jat tribe. Pastoral communities like the Fakirani Jats at one time led nomadic lives moving between Sind in Pakistan and Kutch in Gujarat and trace their lineage to the valley of the Indus. The associative meaning of the design is not known, it is believed to provide protection from the evil eye. Perhaps the bangle is a phallic emblem worn to enhance fertility. From time immemorial humans have linked materials and decorations to the metaphysical and endowed them with divine powers. The power of patterns like zigzag lines, wavy lines, and dots is not just decorative but follows a strict preordained arrangement carefully chosen to fulfill a function.

For affluent people jewelry conveyed wealth and social position; emperors and maharajas adorned themselves with the most spectacular jewels as an advertisement of their sovereignty (fig. 1.23). To those people who lived in close harmony with nature and who were economically, culturally, and even spiritually dependent on it for their survival, jewelry played a far more important role. The casual manner in which large, heavy, and seemingly uncomfortable pieces of jewelry were worn at all times indicates a belief in their power

to fend off *nazar*, or the "evil look," keep malevolent spirits at bay, attract good luck, and protect the wearer from all kinds of disease.

The *kanthla*, a necklace (see fig. 2.30), has a series of die-stamped plaques strung on a black cord. The four pendants on each side are decorated with peacocks, and the central amulet box has a blank image area within a cusped arch to accommodate a favorite god or goddess. If the necklace were made for a Muslim customer, the image area would be inscribed with verses from the Koran or simply set with a stone. Even the *patri haar* (see fig. 2.29) is rich in symbolism. The rectangular and triangular plaques, as well as the square pendant, are decorated with applied flower motifs that symbolize the sun.

In the ultimate analysis, jewelry was adornment, and the size and quantity of adornment was often inversely proportional to the poverty of those who wore it. The tinkling bells of an anklet and the sparkle of gems and faceted elements around the neck were seductive; the sight of arms encased in beautifully patterned silver or gold from wrist to shoulder was captivating; a head ornament hidden behind a veil, a pendant nestling between the breasts, or a waist jewel concealed in the folds of a voluminous skirt—all served as culturally important works of art. It is because ornaments in India have cultural, social, and ritual significance that they are made from prescribed materials, to specific designs, decorated with particular motifs, and created only by those who are divinely mandated to craft them.

THE *SONAR* (GOLDSMITH)

There are three distinct categories of Indian jewelry. Gold ornaments set with precious gems that were made for royalty and the affluent, jewelry crafted mostly from silver, and tribal adornment made from base metals, such as brass, bronze, and copper, and organic materials, including shells, feathers, bone, and ivory. The common thread uniting these categories is the *sonar*. The term *sonar* is derived from *sona*, meaning "gold." Although the jeweler is known as *sonar* or *soni* (one who works in gold), he also works in silver and base metals. The surname Soni, adopted by members of the gold-smith community, is not universal throughout India, and goldsmiths are known by different surnames in different parts of the country. In Rajasthan, the most common surname is Soni; other surnames are Sharma and Varma. In Gujarat, traditional names include Choksi, Parekh, Mahajan, and Minawala; and in South India, those who make jewelry commonly bear the names Achari, Arkachari, and Thangavelu.

While the genesis of Indian civilization might have occurred on the banks of the Indus River, the earliest Indian religious texts, such as the Vedas, which were composed between about 1500 and 1000 BCE, attribute creation itself to Lord Vishwakarma (*vishwa* meaning "universe," and *karman* meaning "maker"). Vishwakarma, "the Primordial Maker of the Universe," was on par with Brahma, "the Creator." In the Rig Veda, Vishwakarma is described as "the one all-seeing god, who, when producing heaven and earth, shapes them with his arms and wings; the father, generator, disposer, who knows

all worlds, gives the gods their names, and is beyond the comprehension of mortals."[20] Like the Greek Hephaestus and the Roman Vulcan, Vishwakarma is credited with constructing the magnificent palaces of the gods, building their celestial vehicles, forging their powerful weapons, and crafting all their precious jewelry. Vishwakarma's five sons were Manu, Maya, Tvashta, Shilpi, and Visvajna, also known as Daivjna, primogenitors of the blacksmith, carpenter, metal caster, stonemason, and goldsmith respectively. According to Ananda Coomaraswamy, these five are "organic" and "indispensable" to the "agricultural village community."[21] In fact, the Vishwakarmas even claim credit for being the "real architects of the Indus Valley civilization,"[22] wherein the arts and sciences were highly advanced, and skilled craftsmen such as architects, weavers, potters, and jewelers made it a thriving center of trade.

The caste structure, as well as the exact positioning of the artisan community within the four-fold Hindu caste system,[23] is complex and ridden with contradictions. The title Vishwakarma, or Vishwa Brahmin[24] as they call themselves in some parts of India, is a relatively late appropriation. In South India the occupational caste made up of the "Tattan (goldsmith), Kannan (brasssmith), Tac'chan (carpenter), Kal-Tac'chan (stone-mason), and Kollan or Karuman (blacksmith),"[25] is known as Kammalan. Origin stories, some divine some mythological, and others with vague foundations in history[26] abound in different regions. Every *soni* subcaste (*jāti*) has its own unique story tracing the genesis of the community either to Lord Vishwakarma or to the Brahmin and Kshatriya castes.[27]

Goldsmiths in most parts of India, especially South India and Bengal, consider themselves to be descended from Vishwakarma and along with the four other communities (blacksmiths, carpenters, metal casters, and stonemasons) occupy an ambivalent position in the Hindu caste order, neither at the topmost nor at the bottommost rung. While "Brahmanical texts describe them as *silpis* and relegate them to the rank of *sudra*" (lowest of the four traditional castes),[28] they credit themselves with the primordial act of creation and trace their origins to the "pre-brahminic and pre-caste period."[29] By virtue of the fact that they "built temples, sculpted the deities, made their ornaments and these were pure and sacred acts,"[30] they claim a social prestige equal to the Brahmins (the uppermost caste).

Bhagwan Das, Dharmendra, and Roopkishor said they were Brahmaniya, or Brahmin *sonis*. They wore the sacred thread, were vegetarian, and therefore of high caste. Hanuman maintained that he was a Medh or Mair Kshatriya *soni* descended from Rajput warriors.[31] None of the four *sonis*, however, was familiar with the concept of a deity called Vishwakarma being the progenitor of goldsmiths or even of a Vishwakarma caste. While the origin of Lord Vishwakarma as the patron deity of the artisan class is mired in myth and controversy, as is the Brahmin lineage that some of them lay claim to, what is captured in the oral histories of the community is their migration from Sind and the Indus Valley to Rajasthan and other parts of India. Generations ago, the forefathers of Bhagwan Das and Roopkishor came to India from Sind, and more specifically from the environs of Mohenjo Daro, the city that the Vishwakarmas claim to have built.

Iconographically, Vishwa-karma is represented as a bearded old man with four arms who appears with his five young sons paying obeisance to him (fig. 1.24) or, alternatively, as a young man with five faces and ten arms holding various instruments and objects. It is important to note that in spite of the status of Vishwa-karma as a deity, there are very few temples dedicated to him in India.[32] Artisans in Bengal and some other parts of India, how-ever, celebrate Vishwakarma Jayanthi on September 17th every year when they worship their looms, crucibles, tools, and other implements of their respective occupations. Coincidentally, September 17th is the same date that the women in Dharmendra Soni's family worship the goddess Jagdamba by drawing a diagram on the wall of their house and calling upon the goddess and ancestors to bless their home.

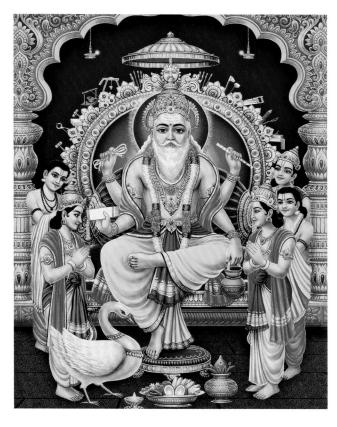

1.24 Lord Vishwakarma, "the Primordial Maker of the Universe" and the god of craftsmen, is often depicted as an old man flanked by his fives sons.

The mystical-magical geometric diagram (see fig. 2.17) in Dharmendra's home is in the form of a parallelogram with four gateways, divided into nine equal squares, and simulates a human standing figure with protruding arms on the sides, feet at the bottom, and the head inscribed with the auspicious letter OM. Five figures are arranged in the squares formed by the intersecting axes within the parallelogram. Another figure at the bottom is holding a string attached to a mat on which a figure is lying. The sun and the moon on top signify good and evil, the peacocks on the two arms are symbols of peace, the swastika embodies auspiciousness; there are drawings of a snake, scorpion, and a flower. The drawing closely resembles the *sanjhi* drawings made by unmarried girls all over Rajasthan in honor of the mother goddess Sanjhi or Sanjhya as a prayer for the blessings of ancestors, the fulfillment of wishes, and a good husband.[33] The patron deity of the *sonis* of Jaisalmer is Hinglaj Devi or Hinglaj Mata (fig. 1.25), a personification of Durga. *Sonis* and their families all go on annual pilgrimage to Ludharwa, the ancient capital of Jaisalmer, where the Hinglaj Devi Temple is located. Prior to the partition of India and Pakistan, a large number of *sonis* lived in Sind[34] and Baluchistan where the original temple of Hinglaj Devi is located.[35]

The *sonis* learned their skills from their respective fathers, who were also goldsmiths. In accordance with the "*guru-shishya param-para*"—the tradition of father assuming the role of guru, or teacher, and transmitting his knowledge to his son, the *shishya*, or student—

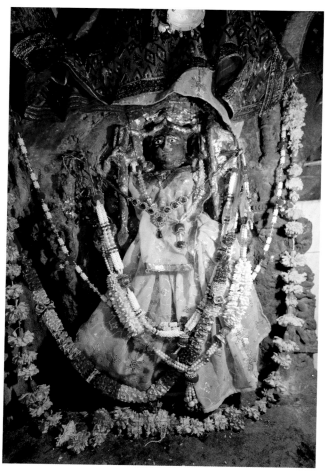

1.25 The idol of Hinglaj Devi, the patron deity of the *sonis* of Jaisalmer, appears in her eponymous temple in Ludharwa, near Jaisalmer.
PHOTOGRAPH BY THOMAS K. SELIGMAN, 2012.

they were all apprenticed to their father or to an uncle (see figs. 2.4, 2.16). Their learning consisted of watching, listening, practicing, performing small tasks, and eventually executing assigned pieces of work to the satisfaction of their teacher. The *soni* designs the piece of jewelry; casts, beats, and twists metal into forms; sets gems; decorates surfaces with patterns and enamel; and finally polishes the finished piece. The vocation of a *soni* is strictly the domain of men, and women are neither trained nor allowed to work in the profession. Shyama Devi, however, the *patua*, or stringer (see fig. 2.25), who threaded the individual spike elements made by Dharmendra into a beautiful flexible bracelet, is a woman from the Lakhera caste, a community traditionally associated with making shellac bangles.[36] Throughout Rajasthan, women of the Lakhera caste string pendants and individual components into necklaces and bracelets.

The act of manufacturing a piece of jewelry is sacred and akin to creation. When we watched Hanuman pour molten metal into the hollow mold, there was complete silence in the workshop as four pairs of lips—those of Hanuman and his three sons—moved in silent prayer to the steady flow of liquid silver (see fig. 2.39). Hanuman was an artist engaged in the act of creation. The process of transforming a lump of shapeless metal into a beautiful object of adornment was not only a manual task but also a spiritual ritual. For, as Ananda Coomaraswamy explains, "The craftsman is not an individual expressing individual whims, but a part of the universe, giving expression to ideals of eternal beauty and unchanging laws, even as do the trees and flowers whose natural and less ordered beauty is not less God given."[37] It is this spiritual act of creation that makes every piece of jewelry unique and induces the craftsman to remain anonymous. Though a piece of jewelry is not signed or stamped with a hallmark, it bears the fingerprints of its maker. No two jewelry items are identical and no two pieces within a pair are exactly the same. An extra granule, a wire that did not get perfectly twisted, a slightly off-center flower—each piece is unique. It was only on the urgings of Tom Seligman and myself that Roopkishor agreed to sign his creations.

Among the five sons of Vishwakarma, it is the descendants of Visvajna (the goldsmith) who are accorded the most respect in a

society that is organized on rigid caste lines. The *soni* is not of the highest caste but calls himself a Brahmin; though male, he was privileged to enter the zenana (women's quarters) and execute commissions in the presence of women; he was viewed with suspicion but was trusted with gems and metals of high value; and even though he was illiterate, he had the greatest technical expertise. For the most part, the repertoire of the craftsman was restricted to traditional designs that were in demand by local communities. As Oppi Untracht states, "Technical competence in selected skills was stressed above design originality, which was less in demand because traditional jewelry styles were perpetuated."[38]

Hanuman, for example, continues to replicate traditional forms with the same decorative details, perhaps bound by the sanctity of meaning enshrined in them. While the price of the metal may be too high to allow for the liberty of experimenting with new forms and designs, Hanuman, like most goldsmiths, follows a structured, coordinated, and synchronous division of tasks in the workshop that is efficient and time saving and that he is reluctant to change to try something new.

Bhagwan Das and Roopkishor have, however, broken away from the confines of tradition and experimented with new techniques. While retaining traditional designs, the use of gold foil and gold polish have transformed the necklaces, earrings, and rings made by Bhagwan Das. Mythology and historical and political narratives are the inspiration for Roopkishor's designs. His ability to visualize the entire sequence of images and lay them out precisely to scale on sheet metal is exceptional. The variety of techniques that are known and employed is manifest in the fourteen items that were specially made for this exhibition. Hanuman's pieces are sand cast and then engraved, incised, and punched with designs, and Dharmendra's necklaces are die-stamped and combine repouseé and filigree. Perhaps the greatest compliment of the goldsmith's work comes from the observation of Edgar Thurston in the late nineteenth century who noted, "With his miserable tools the Hindu goldsmith turns out work that well might, and often deservedly does, rank with the greatest triumphs of the jeweller's art" (fig. 1.26).[39]

The transformation that is taking place in the artisan community is elucidated in Tom Seligman's essay on the four *sonis*, which follows. They straddle the rural and the urban, the traditional and the modern as they reinvent themselves to adapt to the challenges of a rapidly changing world. Departing from tradition Bhagwan Das no longer manufactures jewelry himself but has stayed true to his caste occupation by becoming a retailer of jewelry (see fig. 2.5). He has seized the opportunity afforded by arrivals of large tourist groups in Jaisalmer to offer his expertise and knowledge to an international clientele, which he has assiduously cultivated. His sons first went through the process of apprenticeship with their grandfather and uncles and learned to craft jewelry, but they were then trained by Bhagwan Das in the commercial aspects of the jewelry business. Dharmendra and Roopkishor both handcraft jewelry themselves in their workshops and then sell their pieces directly to customers. Roopkishor's father was dynamic enough to use his exceptional skills to visualize,

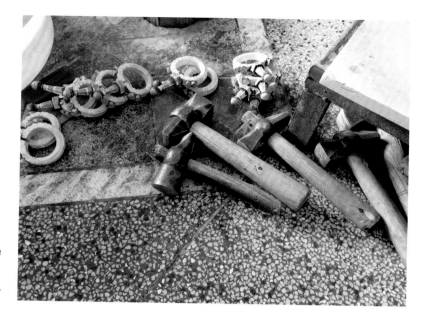

1.26 Simple, basic tools like these are used by jewelers throughout India.

PHOTOGRAPH BY THOMAS K. SELIGMAN, JAISALMER, RAJASTHAN, 2014

experiment, and create a new genre of jewelry that his sons now manufacture.

Hanuman is perhaps the only one of the four *sonis*, who continues to conform to tradition. He painstakingly hand manufactures every piece and supplies shops in the local market (see fig. 2.36). His only concession to modernity is an electric metal press that enables him to manufacture more pieces in a shorter period of time. Hanuman has trained his sons in jewelry manufacture, and they continue to be apprenticed to him, learning the many technical aspects of the art and executing assigned tasks. Hanuman's son Jeetu has expressed a desire to forsake the family trade and pursue a career in computers in the city. As a Medh *soni*, however, Hanuman insisted that his son uphold the pride of his "warrior" lineage and learn the trade into which he was born. It is this hereditary transmission that results in the continuity of skills and the perfection of accumulated generations of artistry and finesse. The lure of the city and a nine-to-five, white-collar job, however, still tempts Jeetu.

Nestling in a landscape of golden sands, the city of Jaisalmer is home to more than 150 *sonis* and their families. At the foothills of the medieval Sonar Quila, or Golden Fort (see fig. 2.2), which rises like a colossus over the city, is a quarter known as the Sona Mohalla, or the Golden District (see fig. 2.3). While the Brahmin *sonis* work and reside in the Sona Mohalla, the Medh *sonis* are scattered in the bazaar area, but all are engaged in their hereditary craft and occupy a unique place in society.

NOTES

1. *Mand* is a style of singing that is typical of the folk music tradition of Rajasthan. The rendition of songs is complex, sophisticated, and very lyrical.
2. Manganiar is a Muslim community of folk musicians from the Jaisalmer area.
3. James Tod and William Crooke, *Annals and Antiquities of Rajasthan: or, The Central and Western Rajput States of India* (London: H. Milford, Oxford University Press, 1920), 1–2.

4. Thomas H. Hendley, *Indian Jewellery*, reprint (Delhi: Low Price, 1995), 17.
5. Both sites are located in present-day Pakistan.
6. Usha R. Balakrishnan, *Alamkāra: The Beauty of Ornament* (New Delhi: National Museum, 2015), 37–69.
7. Jonathan Mark Kenoyer, "Ornament Styles of the Indus Valley Tradition: Evidence from Recent Excavations at Harappa, Pakistan," *Paléorient* 17, no. 2 (1991): 96.
8. Kenoyer (see note 7, above).
9. Kenoyer (see note 7, above).
10. Pravina Shukla, "The Study of Dress and Adornment as Social Positioning," *Material History Review* 61 (Spring 2005): 5.
11. Ananda K. Coomaraswamy, *The Indian Craftsman* (London: Probsthain, 1909), 68.
12. Paul Craddock, Caroline Cartwright, Kirsten Eckstein, et al., "Simple Sophistication: Mauryan Silver Production in North West India," *Technical Research Bulletin* 7, The British Museum (2013): 91.
13. Hanuman Soni related this to me in conversation, while he was crafting the necklace on October 26, 2014.
14. Waltraud Ganguly, *Earring: Ornamental Identity and Beauty in India* (Delhi: B. R. Publishing, 2007), 223.
15. Ganguly (see note 14, above), 211.
16. Rene Van der Star, *Ethnic Jewellery: From Africa, Asia and Pacific Islands* (Amsterdam: Pepin, 2002), 119.
17. Sir Thomas Roe, *The Embassy of Sir Thomas Roe to the Court of the Great Mogul, 1615–1619, as Narrated in His Journal and Correspondence,* ed. William Foster (London: Printed for the Hakluyt Society, 1899), 378–79.
18. B. K. Chaturvedi, *Jewellery of India* (New Delhi: Diamond Pocket Books, 1991), 56.
19. Oppi Untracht, *Traditional Jewelry of India* (New York: Harry N. Abrams, 1997), 30.
20. Ralph, T. H. Griffith, trans., *The Hymns of the Rig Veda*, 2nd ed. (Benaras: E. J. Lazarus, 1896), bk. 10, hymns 81 and 82. See also <http://www.sacred-texts.com/hin/rigveda/index.htm>.
21. Coomaraswamy (see note 11, above), 1.
22. Varghese K. George, "Globalisation Traumas and New Social Imaginary: Visvakarma Community of Kerala," *Economic and Political Weekly* 38, no. 45 (Nov. 8–14, 2003): 4794.
23. The four castes are: Brahmin (priests and teachers), Kshatriya (kings and warriors), Vaishya (agriculturists and merchants), and Shudra (laborers).
24. Since they wore the *janeu*, or sacred thread, and performed religious ceremonies, they were akin to Brahmins, the uppermost caste.
25. Edgar Thurston, *Castes and Tribes of Southern India*, vol. 7 (New Delhi: Asian Educational Services, 2001), 412.
26. See the appendix to this volume, which contains examples of origin stories collected by Thomas Seligman during his fieldwork.
27. Babubhai Soni, a Tapodan Brahmin *soni* and a leading member of the Soni community related this to me in an interview in Mumbai in September 2013.
28. R. N. Misra, "Silpis in Ancient India: Beyond Their Ascribed Locus in Ancient Society," *Social Scientist* 39, no. 7/8 (July–August 2011): 43.
29. George (see note 22, above), 4795.
30. George (see note 22, above), 4795.
31. The four *sonis* (goldsmiths) featured in this exhibition—Bhagwan Das, Dharmendra, Roopkishor, and Hanuman—are all Hindus though a vast number of goldsmiths, silversmiths, enamelers, and other specialist jewelry craftsmen in India are Muslim.
32. Vishwakarma temples are located in Mehsana in Gujarat, Chitor in Rajasthan, and in Aihole in Karnataka.
33. The Indira Gandhi National Center for the Arts, New Delhi, has undertaken a project documenting the tradition of *sanjhi*. A detailed documentation of the rituals, worship and motifs can be found on their Web site at <http://ignca.nic.in/sanjhi/about_project.htm>.
34. See chapter 2 of this volume, pp. 47, 71.
35. The temple is in a town called Hinglaj on the Makran Coast in the province of Baluchistan, Pakistan.
36. See chapter 2 of this volume, pp. 59, 60.
37. Coomaraswamy (see note 11, above), 75.
38. Oppi Untracht, *"The Indian Goldsmith." Icons in Gold: Jewelry of India from the Collection of the Musée Barbier-Mueller*, ed. Laurence Mattet (Paris: Somogy Art, 2005), 63.
39. Edgar Thurston, *Castes and Tribes of Southern India*, vol. 6 (New Delhi: Asian Educational Services, 2001), 394.

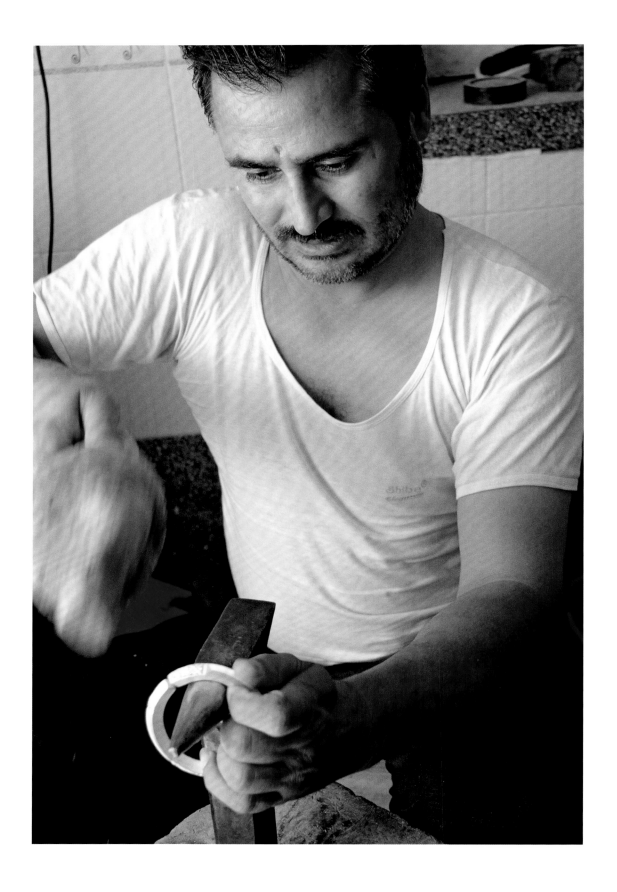

FOUR *SONIS* FROM JAISALMER

Thomas K. Seligman

CARAVAN TRAVEL ACROSS THE THAR DESERT, which dates to ancient times, formerly connected India with Persia, Egypt, and other important centers to the west. The city of Jaisalmer, which from its inception was a caravan stop, lies at the heart of the Thar and today has a population of about eighty thousand. It is built on a yellow sandstone ridge cropping out of the surrounding desert plain. In 1156 CE, with the area prospering from taxation of the camel caravans, the Rajput king Maharawal Jaisal Singh built a fort on the top of this ridge to withstand competition and attack from powerful rulers of Jodhpur, Bikaner, and other kingdoms in Rajasthan and Sind. The fort is now a UNESCO World Heritage Site (fig. 2.2)

The prosperity of Jaisalmer meant that many skilled craft traditions developed there, including leatherwork, stone carving, jewelry making, and silverwork. Jaisalmer's good fortune, however, declined seriously when Bombay developed as a seaport, as trade by ship was much faster and more profitable than by camel caravan. After independence in 1947 and the partition of India and Pakistan, Jaisalmer became an important outpost for the Indian military. In subsequent years India began to promote tourism to the area, which today constitutes perhaps the largest segment of the economy. Crucially, development was enhanced by the creation of the Indira Gandhi Canal, bringing life-sustaining water from the northeast to the region.

Today in Jaisalmer there are many *soni* (jeweler) families, and those who have been in the area for many generations are clustered outside the fort in what is called the Golden District (fig. 2.3). Newer arrivals have set up their workshops in a new development located farther away from the fort in the expanding town. Many of these *sonis* have workshops and sales rooms at home in addition to shops in the fort or the nearby bazaar.

After initially visiting northwestern India in 2008, I determined it would be most productive to investigate the *sonis* in the Thar Desert region of Rajasthan and Gujarat, having been told by many *sonis* and fellow researchers that "traditional" jewelry was still very much in demand and use there and that many active *sonis* still worked for local communities. I first visited the Thar region in 2009 to research the origin stories of *sonis* in this region (see appendix) and to investigate their working and production methods. I made broad surveys and conducted in-depth interviews with many *sonis* in Thar villages

2.1 Hanuman bends a bracelet around an anvil with a wooden mallet.
PHOTOGRAPH BY THOMAS K. SELIGMAN, NOVEMBER 25, 2014.

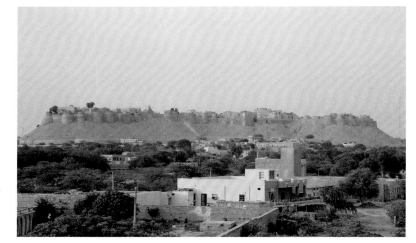

2.2 The Golden Fort, or Sonar Quila, erected at Jaisalmer by the Rajput king Maharawal Jaisal Singh in 1156 CE, viewed here in the distance, has been designated a UNESCO World Heritage Site.
PHOTOGRAPH BY THOMAS K. SELIGMAN, NOVEMBER 2009.

2.3 The older *soni* families generally have their workshops in Sona Mohalla, or the Golden District, in Jaisalmer.
PHOTOGRAPH BY THOMAS K. SELIGMAN, OCTOBER 2011.

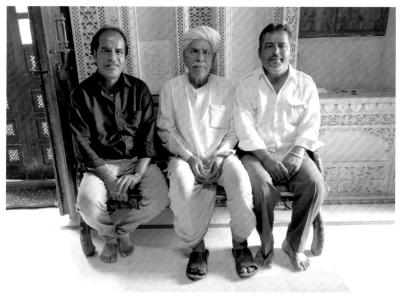

2.4 Bhagwan Das Soni (known as B. D.) appears at the left; in the center sits his father, Govindlal; and to the right is B. D.'s youngest brother, Ram Chandra Soni.
PHOTOGRAPH BY THOMAS K. SELIGMAN, OCTOBER 30, 2014.

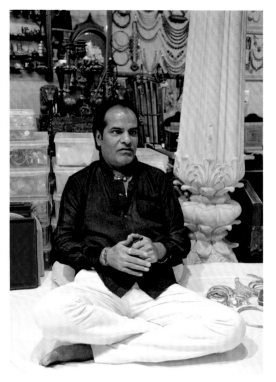

and towns, finally determining to focus intensively in Jaisalmer and in particular on several *sonis* who are both excellent artists and highly respected in their communities. These *sonis* know each other well, and in some cases they have collaborative working relationships; while in others they are competitive. I hope that each of their stories will contribute to a greater understanding of these individuals and will stimulate further research on other *sonis* to correct the historic perspective that these well-trained, and in some cases gifted, artists are, as most of the literature on the subject would lead one to believe, simply unnamed artisans making repetitive work for their multitude of clients, ranging from villagers to maharajas.

GOVINDLAL SONI AND BHAGWAN (B. D.) DAS SONI

My friends Om Prakash Kewaliya (Fifu) and Jitendra Kumar Bissa (Jitu), who operate the small hotel where I stayed in Jaisalmer in 2009, introduced me to Govindlal Soni and his oldest son, Bhagwan Das Soni, or B. D. as he is popularly known (fig. 2.4). I was subsequently taken by Jitu on his motorcycle through the old parts of Jaisalmer near the fort and bazaar in the Golden District where Govindlal and B. D. had a large and beautifully carved stone *haveli*, or private mansion, which they had finished building in 2006. There Govindlal and his wife, Sati Devi Soni, lived together with other family members on the upper floors. The lower level was a large showroom managed by B. D. (fig. 2.5)

2.5 B. D. sits amidst jewelry in the large sales room on the lower level of Jewels Haveli.
PHOTOGRAPH BY THOMAS K. SELIGMAN, NOVEMBER 25, 2014.

Govindlal was born around 1932 in Jaisalmer to Inderchand Soni who was also born in Jaisalmer. Inderchand became one of the few *sonis* to work for the royal family who lived in the palace inside the fort (see fig. 2.2). Further enhancing the family's royal connections, the Maharaja of Barisal performed the marriage ceremony for Govindlal's parents. Inderchand's own father's family originally came from Sind to Jaisalmer approximately eight generations ago. Govindlal's mother, Bacchi Devi Soni, died when he was only a year old. Govindlal's own marriage to Sati Devi Soni, who is from Sind, was arranged as is customary, and together they have eleven children, the first seven were daughters, all of whom married *sonis*; and the last four, sons, all of whom are *sonis*.

A spry, bright-eyed man, Govindlal has many siblings, although he is not sure exactly how many. He was taught *soni* work by his father and learned first how to handle copper and later silver, making simple things like toe rings and anklets for the family. As his skills developed, he was taught *kundan* by an elder brother. This stone-setting technique, which is unique to India, uses gold foil pressed tightly around stones to secure them in a gold mount. Govindlal also learned to do *minakari*, or enamel work, on jewelry. Under the guidance

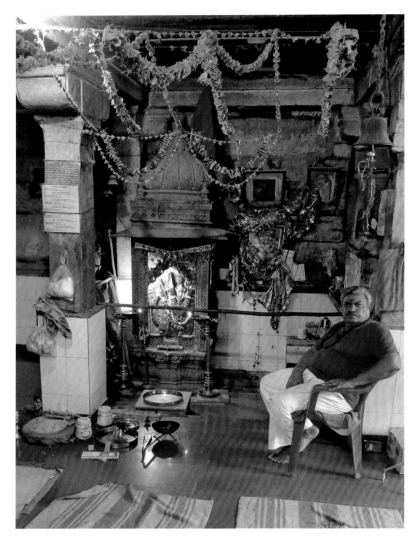

2.6 The principal deity worshiped by *sonis* is Hinglaj Devi. The oldest temple in the region dedicated to her worship is located in Ludharwa, the ancient capital of Jaisalmer. Govindlal and his family make an annual pilgrimage to this site. The temple guardian Mangilal Sewak sits beside the deity.
PHOTOGRAPH BY THOMAS K. SELIGMAN,
NOVEMBER 25, 2014.

of his elder brother, he eventually began working for the royal family as his father had done before he retired.

Govindlal's work for the royal family diminished, however, after it lost its authority and wealth following Indian Independence and the partition of Pakistan in 1947. In the early 1950s he started his own business working with other male family members. He was the first *soni* in Jaisalmer to open a sales shop with an attached workshop in the bazaar in 1964. The shop is still open and is run by Govindlal's youngest son, Ram Chandra Soni. Govindlal remains a skilled *soni*, but due to his age and diminished eyesight, he only occasionally makes gold and gemstone jewelry for his family. He nonetheless remains the patriarch. All of his four sons report their business activities to him, and he is responsible for the overall distribution of the profits within the family. He is also consulted regarding all major investment decisions, and his sage advice is usually well received and heeded. Govindlal keeps up to date by reading the newspaper on a daily basis and continues to be a respected member of the *soni* community.

As a practicing Hindu, he maintains a family shrine in his home for daily offerings. Along with the other family members, he makes an annual pilgrimage to the nearby village of Ludharwa, the ancient capital of Jaisalmer, to the oldest temple of the main deity worshiped by the *sonis*, Hinglaj Devi (fig. 2.6). First built in ancient times, it was rebuilt in 1569 CE and is the temple where castes in the Jaisalmer region that descend from the creator deity Vishwakarma, such as carpenters, stone carvers, blacksmiths, and *sonis*, worship.

As Govindlal does not speak English, I relied on B. D. to translate for me, and this led me into much deeper conversations about his own life and work. B. D. was born on November 12, 1964, in Jaisalmer. He attended school, and when he was about twelve years old, he began to carry Govindlal's bag to the shop in the bazaar before school and help him set up his tools. B. D. had to organize the tools in a prescribed order around the anvil in the floor, and in so doing, he learned their names and uses. After school and on holidays, he apprenticed in his father's workshop learning how to make jewelry by first hammering copper and bronze. As B. D. recalls, his father could tell by the sound of his hammering if B. D. was doing it correctly or needed instruction. After about a year and a half, he was allowed to start working with silver and learning how to shape, file, solder, and finish. When he was sixteen, his father allowed him to start working with gold, and at age seventeen he clearly remembers making his first complete piece, a gold ring that he still keeps at home. After he completed high school, he became a full-time *soni*, further developing his skills.

B. D.'s arranged marriage to Kaushalya Devi took place in 1984, and their first child, a daughter, was born the following year. Thereafter, three sons were born, Pukhraj Soni, Mukesh Soni, and Yogesh Bhagwan Das Soni. All three sons apprenticed to their father and his brothers to learn the skills of a *soni*. Pukhraj today sells gold jewelry in one of the four family shops in the bazaar across the street from Govindlal's original shop.

Mukesh helps in all the shops as needed, while Yogesh is being groomed by B. D. to be a businessman. He completed a degree in economics in 2013 and has since been training to become a *soni* while at the same time traveling to various major cities in India to learn about contemporary fashion trends that will help his father evolve new styles and designs for the thriving contemporary urban markets. B. D. and Kaushalya have raised their family in their own separate home in Jaisalmer.

B. D. has made a serious study of jewelry and can discuss many jewelry traditions, manufacturing techniques, and styles. By the mid-1990s, he had already achieved considerable success and had a large clientele. The showroom he runs in the lower level of his father's home is known as Jewels Haveli. Upon entering, customers leave their shoes on the entry porch and move into a large ground-floor reception area with beautifully carved stone pillars and two elegant staircases. One leads upstairs to the living quarters of B. D.'s father and his family. The other leads down to the showroom full of jewelry from India, Pakistan, Nepal, Afghanistan, and other nearby regions. Every inch of wall space is covered with carefully displayed jewelry. About thirty low chairs for clients surround the central carved pillars

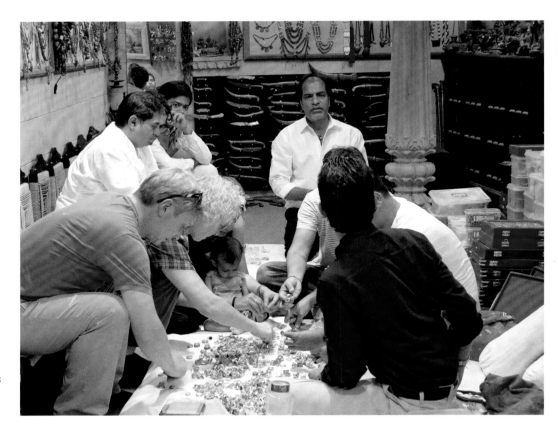

2.7 B. D. Soni shows jewelry to a group of tourists visiting Jewels Haveli.
PHOTOGRAPH BY THOMAS K. SELIGMAN, OCTOBER 27, 2014.

and padded floor mats. Most customers are brought to Jewels Haveli by guides who receive a significant commission from any sale. On occasion entire tour groups arrive, and B. D. and one of his family members will show the customers the many pieces contained in plastic bins in the center of the room (fig. 2.7).

B. D. is a gifted salesman, and as most tourists are not particularly knowledgeable about quality, he will first show people relatively inexpensive silver earrings, bracelets, and necklaces. If he detects that his customers want something more, he will begin to show higher quality and more expensive items, including older tribal, silver jewelry. This older jewelry comes to B. D. from villagers who want to use it as collateral for loans or to sell it for its silver value as determined by the current international price available on the Internet or television. Having considerable experience and resources, B. D. has been able to amass hundreds of older pieces, which he sells for considerable profit. In addition to the guides who bring customers, the luxurious Indian Railway train "Palace on Wheels" began coming to Jaisalmer in 2014 during the cooler season from November to February. To the dismay of many other *sonis* in Jaisalmer, B. D. worked out an arrangement whereby the travelers on this very expensive tourist train are brought directly to Jewels Haveli during their very brief stop in Jaisalmer (fig. 2.8).

In 2004 B. D. took part in a competition sponsored by the state of Rajasthan to determine who would be selected to participate in the Smithsonian Institution Folklife Festival, which is held outdoors on

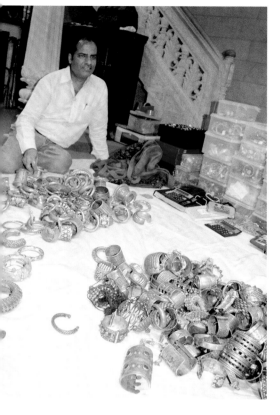

the National Mall in Washington, D.C. As one of the selected artists, B.D. participated in the festival for many years, both demonstrating his workmanship and selling pieces to visitors. He was also able to explain many jewelry techniques, and this gave him considerable exposure to networks that he later developed to sell his jewelry internationally. The festival allowed B.D. to meet jewelers from around the world and to see their work, exchanging ideas, techniques, and designs. In addition he was exposed to the range of prices on the international market for silver and gold jewelry, which I believe have contributed to the pricing strategies he uses at Jewels Haveli.

At present B.D. is primarily a businessman running a very large and profitable jewelry firm. He still occasionally makes gold pieces for his family, and in 2010 he showed me six 22-carat gold bracelets with rubies that he was making for his wife's birthday. These were based upon a design created by his father for bracelets he had made for B.D.'s mother and sister. Govindlal had advised B.D. to make these in what could be called a "family style," and the workmanship was superb, demonstrating that B.D. is still a master. An extended family network of specialist *sonis* who work for Jewels Haveli, however, makes most of the gold-jewelry commissions that he receives from Indian and foreign clients. As silver is not particularly profitable, nor in much demand in modern India, most of the firm's work is done in gold and may include colored stones or gems depending on what the customer can afford.

Indians accumulate their wealth in gold and silver jewelry, and during the important Festival of Lights holiday known as Diwali and the period after the harvest when most marriages take place, there are a huge number of commissions. Customers who want to have pieces made on commission will contact B.D well in advance of these occasions. He will work with the client on the design of the desired pieces, often using large-format books with color illustrations of jewelry to help select a design (fig. 2.9). More recently, designs have been obtained from the Internet and from Bollywood movies. Typically high-carat (22–24) gold is used, resulting in a very yellow tone, and if colored stones are to be included, it must be agreed if they are to be glass, semiprecious, or gemstones. Once the design and embellishments are decided upon, the price is negotiated.

In the past the Maharaja of Jaisalmer established that *sonis* were entitled to a 7.5 percent profit on goldwork, a standard still followed to a degree today. The profit is often taken in a portion of the gold the customer brings to have the jewelry made. As the price of gold has fluctuated greatly in the last few years, B.D. avoids conflict by requiring the client to supply the gold, which is then mixed with

2.8 B.D. Soni displays silver jewelry for examination by prospective buyers.
PHOTOGRAPH BY THOMAS K. SELIGMAN, NOVEMBER 21, 2009.

अनन्त राम कटृटा ज्वैलर्स, जोधपुर. फोन - 2639593, 9314711885

2.9 Gold pieces made on commission by Jewels Haveli appear on the left next to an open gold-jewelry design book used by clients to select the jewelry they want made. Note that the Jewels Haveli piece at the bottom left resembles the illustrated piece labeled number "6" in the deign book.
PHOTOGRAPH BY THOMAS K. SELIGMAN, NOVEMBER 21, 2009.

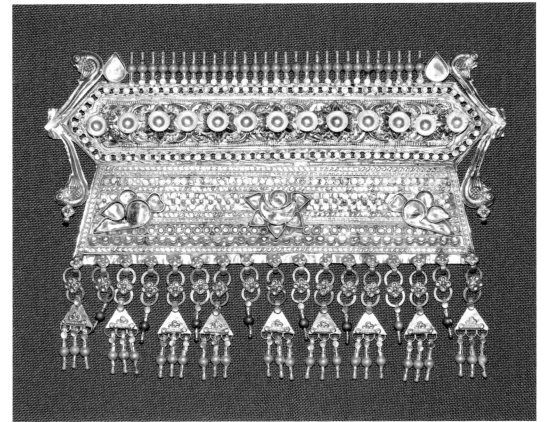

2.11 Most *sonis* do not sign their work, however, B. D. Soni often has the *nimboli* pendants that his firm creates individualized with peacocks placed at the top corners.
PHOTOGRAPH BY THOMAS K. SELIGMAN, OCTOBER 13, 2011.

other metals to make it stronger for jewelry manufacture. For the work he requires a 50 percent down payment, and after the gold form is made, he is paid another 25 percent with the balance due at final delivery. Once the design, size, and price are determined, B.D. has an artist member of his extended family do a detailed drawing of the piece that B.D. reviews with the client. Next a prototype is made in copper for approval by B.D. before the *soni* making the piece begins working in the gold provided. Once the gold is fashioned into the piece, the stones or pearls to be added—their specific size and placement—are reviewed by B.D. The gold piece and the loose stones and pearls are turned over to another member of his family who does the *kundan* setting and the *minakari* (enamel) work, which often appears on the backside of gold jewelry to prevent the gold from wearing with use (see figs. 1.7a,b, 1.8a,b).

In 2010 B.D. took me from the Jewels Haveli showroom down the street to where the stone setting and enamel work are done, usually by his nephews Damodar Soni and Nandu Soni (fig. 2.10). During peak periods, other family members will also perform this work. At the time of my visit, Damodar and Nandu were working on a large pendant for a necklace known as *nimboli*. Once the *sonis* have set the stones and pearls, a member of the Lakhera caste does the specialized work of stringing the various gold elements together with cord. Most artists do not sign their work, but B.D. tells me that often for *nimboli* he has peacocks carved on the top ends where the cord passes through the pendant (fig. 2.11). Once the piece is deemed by B.D. to be proper and complete, he will pay the other *sonis* for their work on it. He will then put the jewelry in a box, which has been specially made by yet another caste, and give it to the client who ordered it, receiving the final payment.

As mentioned earlier B.D. also creates new styles, and in the last few years he has been taking the older silver jewelry he acquires from villagers and modifying it. He removes the glass or old broken stones and replaces them with gold foil over a silver backing. He has taken this idea further by using designs from older tribal silver jewelry and making new versions in silver with integrated gold elements. These sophisticated pieces have become very popular in urban markets because of their high-quality design and workmanship and relatively reasonable price compared to gold jewelry with gems. In 2014 B.D. told me that he was selling quantities of these pieces through retail outlets in New Delhi, Mumbai, and the United States (figs. 2.12–2.15a,b). While these new and growing markets are an important source of income for B.D. and his family, the majority of their work comes from commissions from local people. If the commission is for gold, then B.D. keeps the work within his family, but if it is for silver or for stock in one of his stores, he will commission the work to be done on a per piece basis, supplying the pure silver. B.D. often uses Hanuman Soni (see below) for this work, as he is trusted and skillful.

When I asked B.D. if he could put into words what it means to him to be a *soni* (apart from simply being born into the Soni caste) he replied: "To be a *soni* is to be proud to make beautiful things and to try to make new designs which are beautiful. Also to keep and explore one's traditions."

2.10 Damodar Soni, who works for B.D. Soni, sets stones in a large pendant necklace (*nimboli*) using the *kundan* technique.
PHOTOGRAPH BY THOMAS K. SELIGMAN, JANUARY 7, 2013.

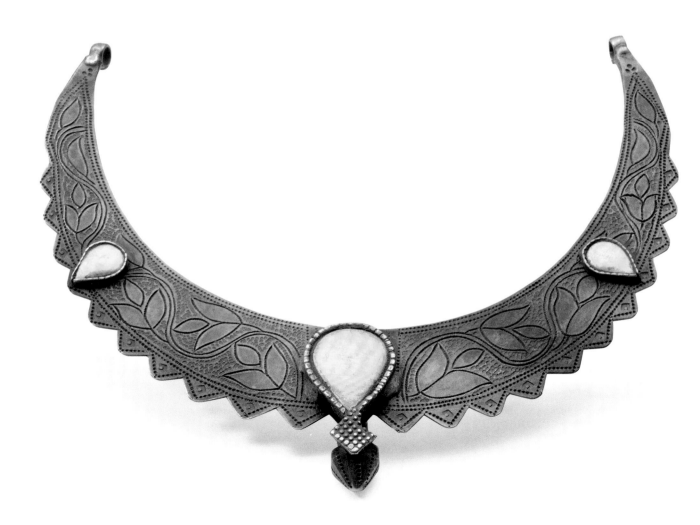

2.12
B. D. (Bhagwan Das) Soni
Necklace, 2014
Silver, gold foil
Diam: 15.5 cm

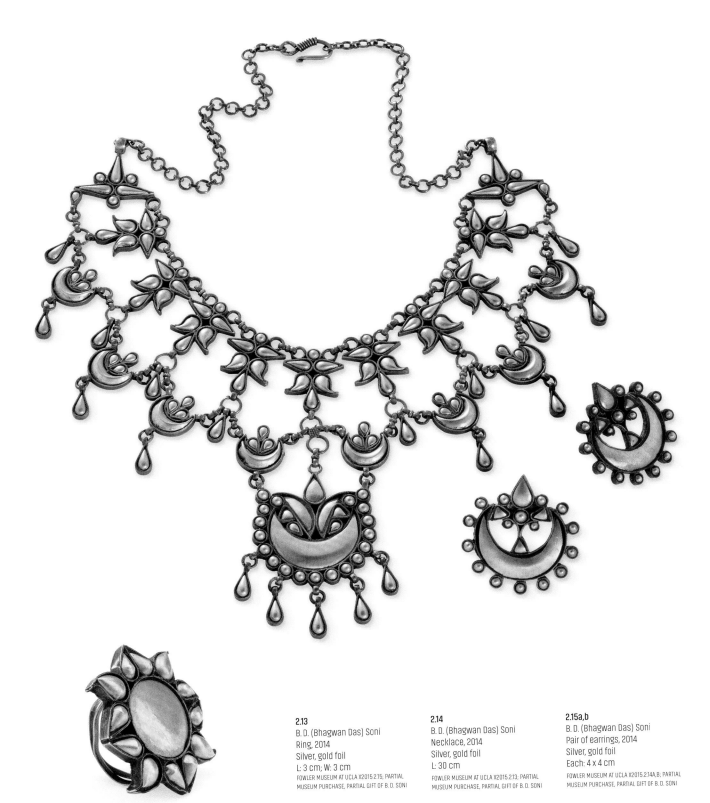

2.13
B. D. (Bhagwan Das) Soni
Ring, 2014
Silver, gold foil
L: 3 cm; W: 3 cm
FOWLER MUSEUM AT UCLA X2015.2.15; PARTIAL
MUSEUM PURCHASE, PARTIAL GIFT OF B. D. SONI

2.14
B. D. (Bhagwan Das) Soni
Necklace, 2014
Silver, gold foil
L: 30 cm
FOWLER MUSEUM AT UCLA X2015.2.13; PARTIAL
MUSEUM PURCHASE, PARTIAL GIFT OF B. D. SONI

2.15a,b
B. D. (Bhagwan Das) Soni
Pair of earrings, 2014
Silver, gold foil
Each: 4 x 4 cm
FOWLER MUSEUM AT UCLA X2015.2.14A,B; PARTIAL
MUSEUM PURCHASE, PARTIAL GIFT OF B. D. SONI

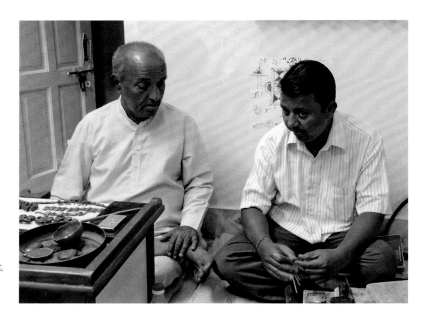

2.16 Deendayal Soni, seated at left, talks with his son Dharmendra.
PHOTOGRAPH BY THOMAS K. SELIGMAN, OCTOBER 20, 2014.

DHARMENDRA AND OM SONI

> To be a *soni* [means] that I have a great sense of pride that through my art and craft, I can bring happiness to other people. When someone criticizes, I take that as an opportunity to learn where I went wrong and to improve.
>
> <div align="center">DHARMENDRA SONI, OCTOBER 26, 2014</div>

Mahadev Jewellers and Om Jewellers are the family businesses run by Dharmendra Soni and his younger brother Om Soni. Dharmendra was born April 9, 1977, and Om four years later on March 1, 1981. Their father, Deendayal Soni (fig. 2.16), and mother, Devai Devi Soni, were married in Jaisalmer, which has been home to Deendayal's family for over five generations. Deendayal's grandfather Jawvanlal Soni made jewelry for the royal family of Jaisalmer, and Deendayal continues to help the royal family by evaluating their old jewels and finding suitable buyers when they wish to sell. Dharmendra and Om's family is Hindu and identifies itself as Brahmaniya, or Brahmin Soni, a sub-sect of higher status within the Soni caste. This explains their custom of following a vegetarian diet similar to that of Brahmins, the highest Hindu caste.

The family goddess is Jagdamba who is depicted on a wall tile in the workshop as well as in the form of a painted prayer design (fig. 2.17). Dharmendra and Om's grandfather constructed a temple in Jaisalmer dedicated to Devi Ashapurna (the one who fulfills desires), and it is frequented regularly by many *sonis*, including Dharmendra and his family. The family also makes annual pilgrimages to the temple of Hinglaj Devi in nearby Ludharwa, the ancient capital of the kingdom of Jaisalmer (see fig. 2.6).

As jewelers to the royal family, the family was formerly very prosperous and owned about forty houses in Jaisalmer. Over the last few decades, however, all of the houses have been sold with the exception of the family house and another across a side alley off the

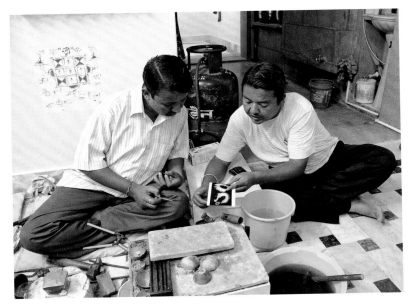

2.17 Dharmendra and Om confer on how best to make spikes for a bracelet commissioned for this exhibition. On the wall behind them is a printed prayer design.
PHOTOGRAPH BY THOMAS K. SELIGMAN, OCTOBER 20, 2014.

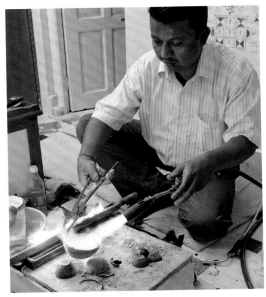

2.18 Dharmendra pours silver into a mold.
PHOTOGRAPH BY THOMAS K. SELIGMAN, NOVEMBER 25, 2014.

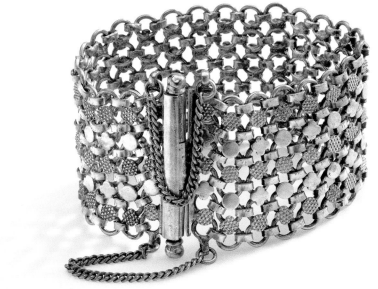

Golden District. The entire family lives in these two unadorned stone houses with the jewelry workshop in the front room of the larger house. It is here that Dharmendra and Om, and occasionally other family members, work—heating, hammering, filing, and soldering gold and silver into beautiful ornaments (figs. 2.18, 2.19).

The workshop is equipped with steel anvils set into the floor, a low work table, and a large machine press that is used to flatten metal into thins sheets and to make wire. There is also a large gas canister for the torch used to melt and solder metal and a small electric buffer to polish finished pieces. The remainder of the ground floor includes a bathroom, kitchen, and bedroom, with a storage cellar below.

2.19
Narshing Soni and Dharmendra Soni
Bracelet, 2012
Silver, mechanically stamped, silver wire, solder
L: 12.7 cm
COLLECTION OF RITA BARELA

This bracelet was commissioned by the author.

2.20 Dharmendra sorts through silver jewelry.
PHOTOGRAPH BY THOMAS K. SELIGMAN, NOVEMBER 16, 2010.

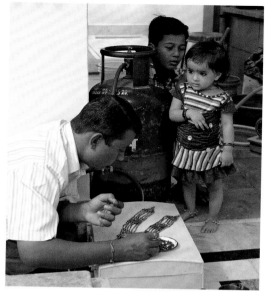

2.21 Dharmendra sets glass pieces into a necklace commissioned for the Fowler Museum.
PHOTOGRAPH BY THOMAS K. SELIGMAN, NOVEMBER 25, 2014

On the second floor are two rooms with thin mattresses on the floor where Dharmendra and Om show their tourist customers silver jewelry that they have made particularly for this clientele (fig. 2.20). They also have older pieces of silver jewelry available. Dharmendra either purchases these on trips he makes to villages specifically for this purpose, or he buys them from villagers who come to Jaisalmer to sell or pawn their silver jewelry. The salesrooms are converted into bedrooms for the family at night. The third floor of the house has two additional bedrooms and stair access to the roof.

Dharmendra went to school through the twelfth grade before taking up jewelry making full time (fig. 2.21). He was trained by his father and his uncle Narshing Soni, and he remembers that his first complete piece was a silver anklet. After two years of working with silver, he switched primarily to gold. Om, who spent a shorter time in school, learned in his early years from his father but was then sent to Jaipur, the capital city of Rajasthan, to train in goldwork as an apprentice to another uncle.

Dharmendra's arranged marriage in 2000 to Jasode Soni, also from Jaisalmer, was an important family event lasting five days. Jasode's father gave Dharmendra about 150 grams of gold for his daughter's dowry, which Dharmendra then made into jewelry for his new wife. Since their marriage they have had a daughter, born in 2001, and a son, born in 2004. Om's arranged marriage to Chanchal Soni took place in 2007, and with the gold provided by his father-in-law, he also made his wife jewelry. Om and Chanchal now have three daughters between the ages of four and ten.

The older children are in school, and Dharmendra's son is starting to apprentice in jewelry making. Dharmendra believes that ten or eleven years old is the right age to begin training to become a *soni* and that if one waits past the age of eighteen, it is too late. The younger girls are around the house all day with their mothers and their devoted grandmother Devai Devi. While working, Dharmendra and

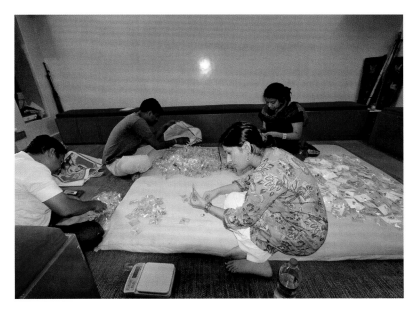

2.22 Om Soni sells jewelry to
Indian customers.
PHOTOGRAPH BY THOMAS K. SELIGMAN,
OCTOBER 13, 2011.

Om are seated on the workshop floor, and the children play freely around the house and are only chided when they get too close to a dangerous tool or hot piece of metal that could harm them (see fig. 2.21). The two fathers are quite attentive to the girls even when this disrupts their work.

About ten years ago Deendayal made Dharmendra responsible for all the family's major business and investment decisions, as he has great confidence in his son's business abilities. Deendayal leaves the house each day to manage the family shop in the bazaar where he primarily handles commissions from local people for gold jewelry to be made by Dharmendra and Om. At present the family specializes in making gold jewelry, as it is more lucrative than silver. The exception is the silver items that they make for tourists, which are significantly marked up, both for profit and to cover the commission that must be paid discretely to the guides who bring in these customers.

When tourists arrive at the house, they customarily leave their shoes on the front porch. Dharmendra or Om first receive the guests in the workshop where they give a short presentation about silver jewelry making, which they do using items they have prepared specially for this purpose. They have learned this brief education enhances sales once the tourists are in the second-floor showrooms. In the showrooms (fig. 2.22) there are several containers of old silver jewelry and newly made items. After the customers are served chai (tea) or water and it is determined what kinds of jewelry they are interested in seeing, items are spread out on the mattresses for review. Once a customer has selected an item of jewelry, it is weighed on a digital scale and the gram weight is multiplied by the value of silver at the time. To this figure, another amount is added to reflect the complexity of the workmanship in the piece. The value of a piece can vary considerably depending on the price of silver on the international market, and older pieces command a higher price than newer ones due to their antique value. There is no gold jewelry

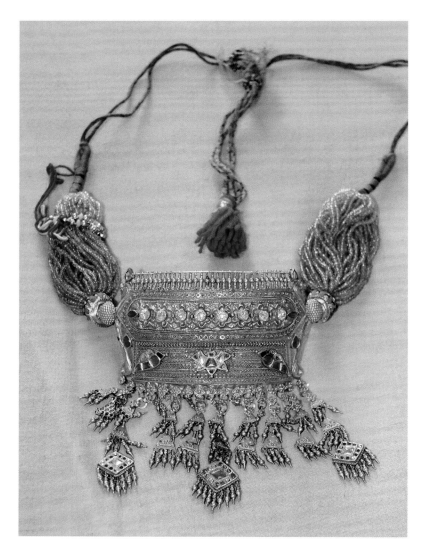

2.23 This *nimboli* (pendant neck-lace) was made by Deendayal Soni for his wife, Devai Devi, with gold supplied by her father as part of her dowry.
PHOTOGRAPH BY THOMAS K. SELIGMAN, OCTOBER 19, 2011.

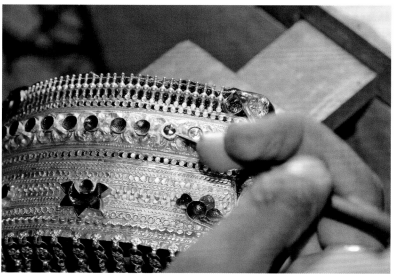

2.24 Sushia Soni, a cousin of Dharmendra and Om, sets stones using the *kundan* technique.
PHOTOGRAPH BY THOMAS K. SELIGMAN, OCTOBER 17, 2011.

shown or sold in these showrooms, as gold pieces are made strictly on commission.

One of the most important items Dharmendra and Om make is a necklace known as *nimboli,* which is an important piece in the marriage dowry of Hindus from the Jaisalmer region (fig. 2.23). Dharmendra and Om fashion the gold base of the *nimboli* out of 23-carat gold. It is then set with colored stones and pearls by their uncle Shankarlal Soni and his two sons Sushia and Manu, all of whom live down the street (fig. 2.24). They take the gold base, which has small cavities with edges to hold the stones, and adhere it to a wooden tool using melted lac (a resinous substance secreted by an insect, *Laccifer lacca*). The stones, with a piece of colored foil placed behind them to create greater luminosity, are inserted into the appropriately sized and positioned cavities. Small pieces of gold foil are pressed tightly around the stones to hold them in place. This is known as the *kundan* process. Pearls are also added using the *kundan* setting technique. Once the stones and pearls are in place and the piece is hand burnished and polished, the lac is melted to release the piece from the wooden tool. It is then ready for the cord work to be done by Shyama Devi, who belongs to the Lakhera caste (fig. 2.25). Often a fabric piece is attached to the back of the pendant to prevent gold from being worn away when the necklace is worn. Dharmendra estimates *nimbolis* cost between US $2,500 and US $4,500 depending on the current price of gold, its weight, and the number of stones. Each stone (not gemstones) costs about $15 to be set. Dharmendra indicates that he and Om have made about forty-five to fifty *nimbolis,* and this particular jewelry item is one of their most important sources of income. While all *nimbolis* are similar, each is unique as the client determines the size, weight, the number, color, and positioning of the stones and pearls, and the color and thickness of the cords. After the marriage ceremonies, the bride will wear her *nimboli* only for festivals and other special occasions. When the necklace is not being worn, she will keep it safely locked up at home.

In the last decade the price of gold and silver has fluctuated widely, and due to the global economic downturn of 2008–2011, the family jewelry business was unstable for a period of time. Dharmendra estimates that the family revenues declined about 30 percent during the period and have only slightly rebounded in the recent years, as tourism has not increased. In an effort to expand their markets, Dharmendra took a trip to five European countries in May 2012 to sell jewelry at fairs and to see if he could make connections with retail operators who would order from him. He was able to use connections he had made with tourists who had visited the family home in Jaisalmer to develop introductions in Europe. Unfortunately, while some sales were made, Dharmendra feels that overall this was not a successful trip, but despite this he remains determined to expand his markets internationally. In 2014 he received a significant commission from a London-based investment banker to create a twelve-piece silver place setting modeled upon a famous European Art Deco design. He completed this and was very pleased with the results, as it was profitable and demonstrated that international orders can be successful. He also received a commission from the

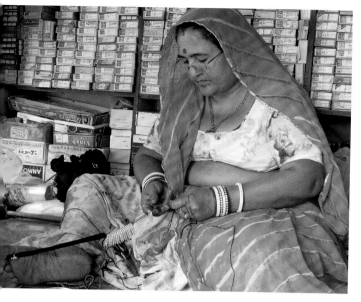

2.25 Shyama Devi Lakhera
strings the elements of a necklace
together for Dharmendra and
Om Soni.
PHOTOGRAPH BY THOMAS K. SELIGMAN,
NOVEMBER 25, 2014.

2.26 Dharmendra mans his booth
at the International Folk Art Market
in Santa Fe, New Mexico.
PHOTOGRAPH BY THOMAS K. SELIGMAN,
JULY 11, 2015.

Fowler Museum at UCLA for four pieces included in the exhibition accompanying this volume (figs. 2.27–2.30).

In late 2014 Dharmendra applied to be included in the International Folk Art Market held in Santa Fe, New Mexico, in July 2015. He was accepted as one of the sponsored artists, which gave him significant support to participate in the market (fig. 2.26). As this was Dharmendra's first trip to the United States, he traveled with Santosh Rathi, a friend from Jaisalmer who deals in textiles and had visited Santa Fe twice before. As this opportunity arose, the ambitious Dharmendra also arranged to show his work at a "fair trade" bazaar at the de Young Museum in San Francisco. While in each city he also used whatever connections he had to sell his works to shops and boutiques.

Dharmendra was somewhat successful in his first foray into the American market, although sales were below what he had hoped. He found that the "tribal" silver jewelry sold much better than the gold with *kundan* work, as his gold is expensive and not in a style that is of interest to most American buyers. In both markets the silver outsold the gold in quantity, but as the gold is priced much higher, the revenue from the limited sale of gold jewelry was greater than that of the silver jewelry. Dharmendra applied again in 2016 for the Santa Fe International Folk Art Market but unfortunately was not accepted. As he says optimistically, "To learn is also to earn."

While Dharmendra is responsible for the family's finances and international marketing efforts, Om and Deendayal remain in Jaisalmer continuing their regular work to keep the business going. Their work remains primarily local commissions for gold jewelry and the sale of their large inventory of older silver pieces and newly made silver earrings and bracelets. This core business is able to sustain the family, but their ambition is to obtain greater wealth so that they can acquire more property in Jaisalmer as a long-term investment, especially as there is only Dharmendra's son to carry on their jewelry business.

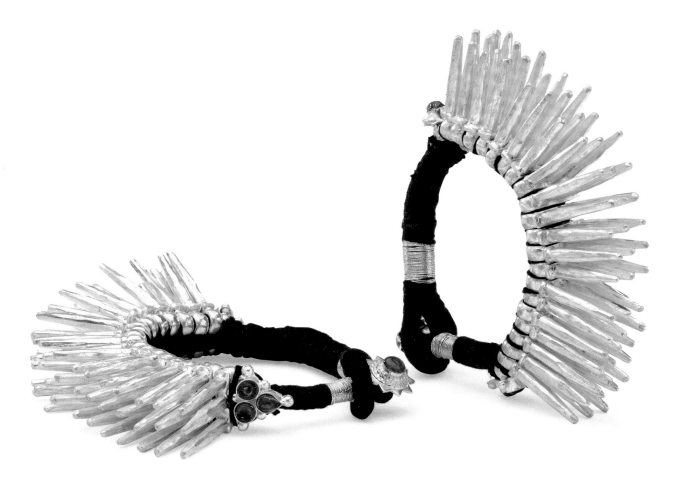

2.27
Dharmendra Soni
Bracelets (*pahunchi*), 2014
Silver
L: 22.5 cm
FOWLER MUSEUM AT UCLA X2015.2.1, 2015.2.2;
MUSEUM PURCHASE

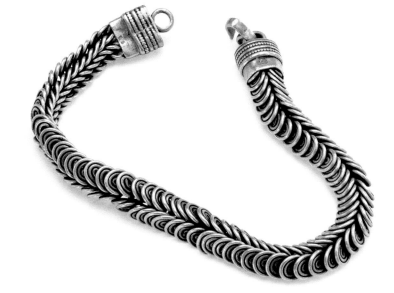

2.28
Dharmendra Soni
Bracelet (*jalebi* chain), 2014
Silver
L: 25 cm
FOWLER MUSEUM AT UCLA X2015.2.8;
MUSEUM PURCHASE

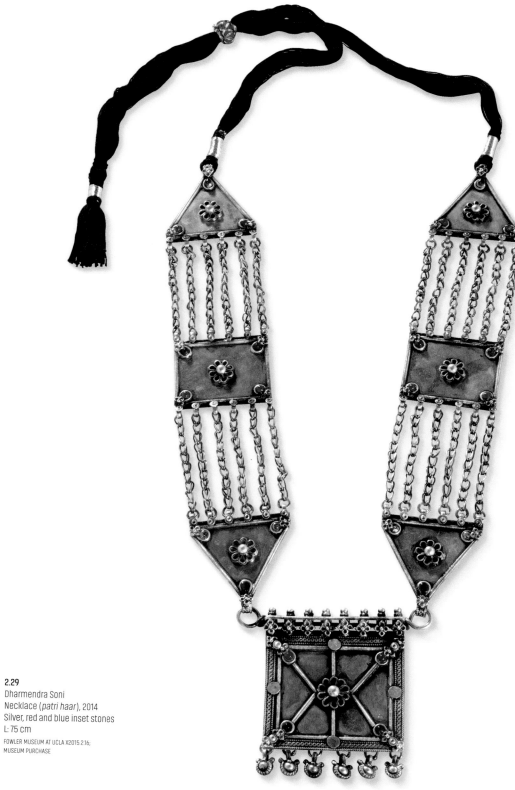

2.29
Dharmendra Soni
Necklace (*patri haar*), 2014
Silver, red and blue inset stones
L: 75 cm
FOWLER MUSEUM AT UCLA X2015.2.16;
MUSEUM PURCHASE

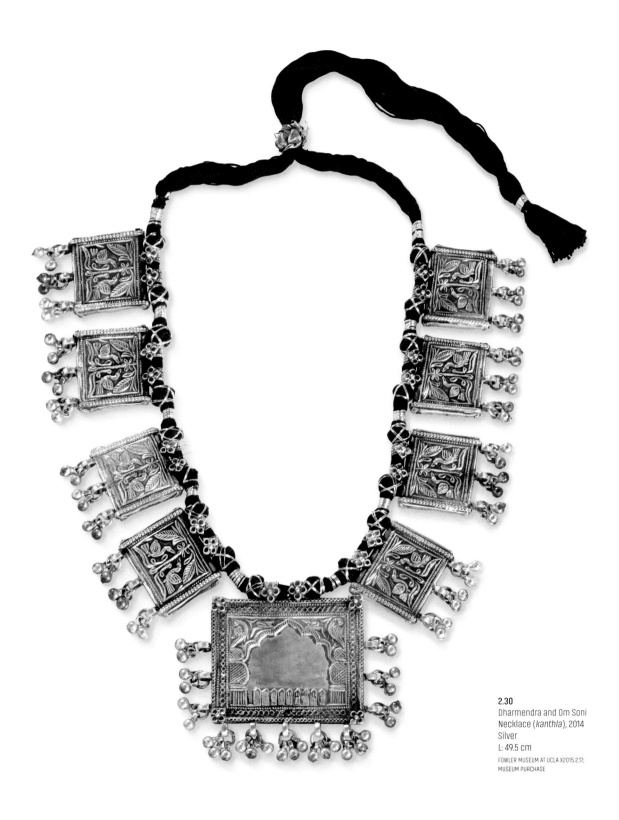

2.30
Dharmendra and Om Soni
Necklace (*kanthla*), 2014
Silver
L: 49.5 cm
FOWLER MUSEUM AT UCLA X2015.2.17;
MUSEUM PURCHASE

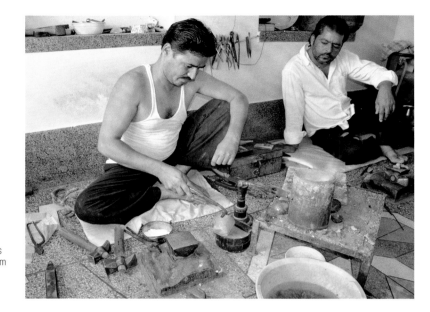

2.31 Hanuman Soni at left pours molten silver into a mold, as Ram Soni looks on.
PHOTOGRAPH BY THOMAS K. SELIGMAN, NOVEMBER 21, 2009.

HANUMAN SONI AND SONS

In November 2009, as I began my research in Jaisalmer, I asked B. D. Soni (see pp. 45–53) about other *sonis* who still made traditional-style jewelry for local people. He told me about Hanuman Soni who makes pieces for Jewels Haveli, B. D.'s store. B. D. then had his younger brother Ram Soni take me over to meet Hanuman, whose home and workshop are located in a newer area of the expanding city. We rode over on Ram's motorcycle, as it is impossible to drive a car through the narrow streets of the old parts of Jaisalmer where the more established Brahmin Soni live and work. We arrived shortly after at Hanuman's new home, which he had built in 2008 with the aid of government subsidies. Hanuman, who speaks only the local Marwari dialect, welcomed me graciously into his workshop, which fronts the street. Sitting on the floor drinking chai (tea) with Ram translating (over the years several other local people who speak English have helped as translators and interpreters as well), I began to learn Hanuman's history (fig. 2.31).

Born about 1972, he grew up in the small village of Raneri, about 150 miles east of Jaisalmer near Jaipur. His father, Binj Raj Soni, was born in the same village around 1936 and became its only jeweler. Binj Raj married Durga Devi, who came from western Rajasthan near Bikaner, and Hanuman was their only child. He attended school in Raneri and finished sixth standard. After this, at approximately fifteen years of age, he began an intensive apprenticeship with his father. He recalls he started by working in silver and later a little gold. The first piece he sold was a beautifully cast ring for a man in Raneri.

In 1990 at age eighteen, Hanuman's family arranged his marriage to Pooran Devi, who comes from a *soni* family in a nearby village. Today they have three sons (fig. 2.32), Jasraj Soni (b. 1992), Jeetu Soni (b. 1994), and Rajendra Soni (b. 1997). About the time his last son was born, Hanuman's father died, and Hanuman decided to move his family to Jaisalmer, as he had little remaining business or family

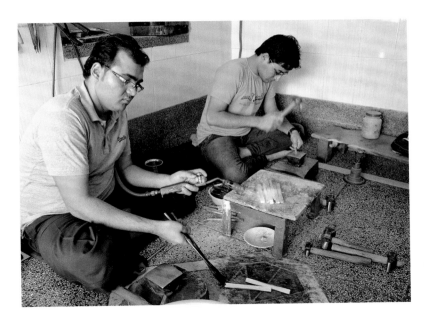

2.32 Jasraj at left and Jeetu at right work in their father's shop.

PHOTOGRAPH BY THOMAS K. SELIGMAN, OCTOBER 22, 2014.

support in Raneri. In Jaisalmer there is a large *soni* community, and Hanuman and his wife both had relatives there. At first they rented a house, and Hanuman set up his workshop making silver jewelry for local people and more prosperous *sonis* who ordered silver items from him. His reputation for honesty, timeliness, and very high-quality work spread, and soon he was able to accumulate enough resources to construct his new home in the Bal Miki Colony near the important Hanuman temple.

Hanuman and his family describe themselves as Medh Soni, a Soni caste also known as Mair Kshatriya Soni, or Medh, in Rajasthan, who trace their origins to Rajput warriors. They are Hindus, and the family goddess they worship is known as Jwalamukhi Devi. As with other *sonis*, they also make an annual pilgrimage to the Hinglaj Temple in Ludharwa (see fig. 2.6). Hanuman has trained his three sons in his workshop, and they all contribute to the family's livelihood. Jasraj began his apprenticeship at age sixteen after finishing school, and similarly Jeetu began his training at age fourteen after his schooling. Rajendra remained in school until age sixteen and only recently began training, but his interests led him to train with Topenraj Soni, who is well known for his goldwork.

While Hanuman, Jasraj, and Jeetu can all work in gold, they very seldom do, preferring to specialize in making large and heavy silver pieces for local people and for between twenty and twenty-five shopkeepers in the bazaar who place orders with Hanuman for their stock. He is thus a direct retail supplier to clients and also a wholesaler to shopkeepers. Hanuman says he really doesn't care if he works in gold or silver, but working with gold requires more mental effort and is more stressful due to its very high value, while silver is more physical, requiring less intense focus than gold. I have never seen him refuse a commission, whatever the requirement, but he is locally known as a *soni* master specializing in massive, heavy silver anklets and bracelets (figs. 2.33–2.35).

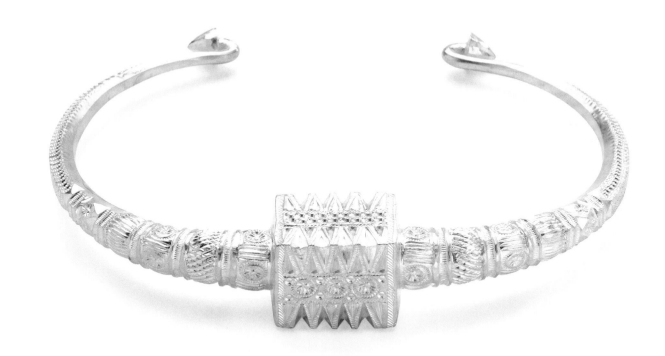

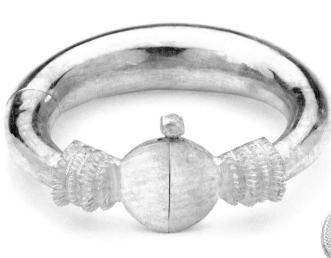

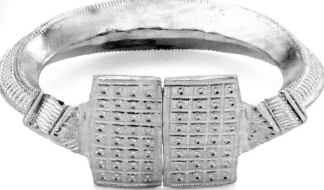

2.33
Hanuman Soni
Necklace (*hasli*), 2014
Silver
Diam: 15 cm
FOWLER MUSEUM AT UCLA X2015.2.7;
MUSEUM PURCHASE

2.34
Hanuman Soni
Anklet (*kadla*), 2014
Silver
W: 9 cm
FOWLER MUSEUM AT UCLA X2015.2.5;
MUSEUM PURCHASE

2.35
Hanuman Soni
Anklet (*kadla*), 2014
Silver
W: 9 cm
FOWLER MUSEUM AT UCLA X2015.2.6;
MUSEUM PURCHASE

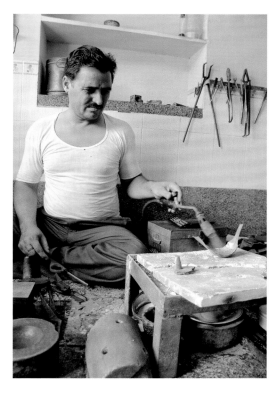

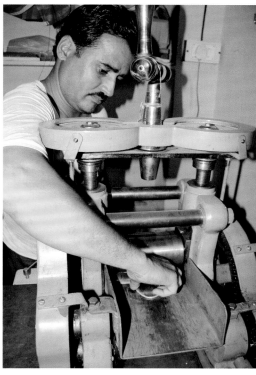

2.37 The electric press that Hanuman was able to acquire in 2013 facilitates the flattening of silver and the making of wire.
PHOTOGRAPH BY THOMAS K. SELIGMAN, NOVEMBER 25, 2014.

2.36 Hanuman heats silver that will be made into an anklet.
PHOTOGRAPH BY THOMAS K. SELIGMAN, NOVEMBER 25, 2014.

Hanuman has taken great care to teach his sons the proper way to make silver jewelry, and they all began by working on heavy solid pieces. The workshop has space for three or four men working together. Different stages of work are ongoing simultaneously, creating an efficient system for making large orders in a timely fashion (fig. 2.36). Work goes on seven days a week, ceasing only if there is a holiday, festival, or funeral. Facing the street is a small glass display case with a few items and Hanuman's cupboard holding his scale and the notebooks that he uses to record the details of his orders. High on the far wall in the corner is a color television usually showing Indian soap operas, but by using his remote control, Hanuman can easily switch to the channel displaying the international prices for gold and silver. Hanuman obtains all of his tools from local *lohars* (ironsmiths) who make hammers, molds, and other tools to specification. Other than a small electric buffing machine and his soldering torch, all of Hanuman's tools are handmade by the *lohar* or obtained in the local market. It was not until 2013 that Hanuman was able to afford the US $1,900 to purchase an electric machine press to flatten metal and make wire (fig. 2.37). Hanuman allows other *sonis* to use his press for a fee based on the gram weight of the metal being worked.

Hanuman and his two older sons specialize in two particular types of silver ornament. The large and heavy anklets worn by women from many different communities in the Jaisalmer region constitute the first type (fig. 2.34). The anklets are made in pairs and are either hollow (in which case they are called *kadla*) or solid (*kadiyan*), depending on the wealth of the person making the order. The solid type is cast in .925 silver with some zinc mixed in for strength. Hanuman

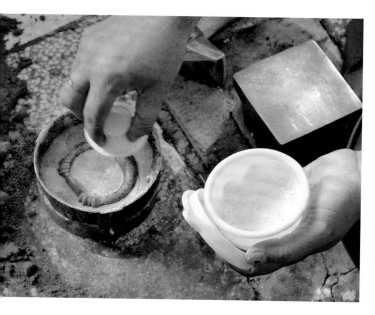

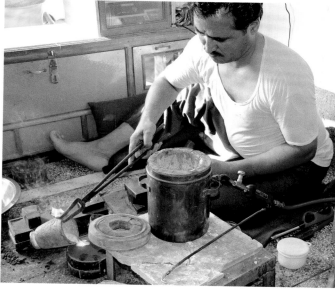

2.38 Hanuman makes a mold for the type of anklet shown in figure 2.34.
PHOTOGRAPH BY THOMAS K. SELIGMAN, NOVEMBER 25, 2014.

2.39 Hanuman pours silver into a mold.
PHOTOGRAPH BY THOMAS K. SELIGMAN, OCTOBER 25, 2014.

has on hand two to three size models that he has made in brass. Once the woman ordering the anklets has chosen the proper size, Hanuman prepares the mold, which consists of two round rings of steel each about six inches in diameter and two inches high. They have an interlocking slot so that they can be put together and remain tightly joined. Hanuman or one of his sons mixes locally obtained fine grain sand with palm sugar as a binder. Then the mixture is put into each half of the mold and tamped down to compact it (fig. 2.38). The brass model is then pressed into one half of the mold until it is flush with the surface of the sand mixture. The brass model is carefully removed, leaving a perfect impression in the mold. Lime powder is dusted into the mold to facilitate the release of the silver that will fill the void in the mold. A small hole is pressed through the sand in the top piece to allow for the molten silver to be poured into the mold. Once the top piece is fitted to the bottom, the mold is ready. Often four or six molds are prepared at the same time for the sake of efficiency. As the molds are being prepared, silver is melted in a ceramic crucible using a gas torch. The silver is poured into the opening in the sand on the top of the mold and completely fills the hollow anklet form (fig. 2.39). The mold is allowed to cool for a few minutes and then is opened. The silver anklet is removed and allowed to cool a bit more before being put into a pan of cold water. Once cool enough to handle, the newly caste anklets are inspected by Hanuman, and the excess silver is removed. One of his sons files the anklet and finishes by polishing with the electric buffer. If surface designs are to be added, they are done using metal stamps to hammer designs into the silver surface, and grooves may be filed into the ends of the anklet to give more sparkle.

As noted earlier, a hollow and more affordable anklet can also be made, and this is what I commissioned for the Fowler Museum in 2014 (fig. 2.40). This process begins with melting about 175 grams of .925 silver and a bit of zinc and a white chemical powder called

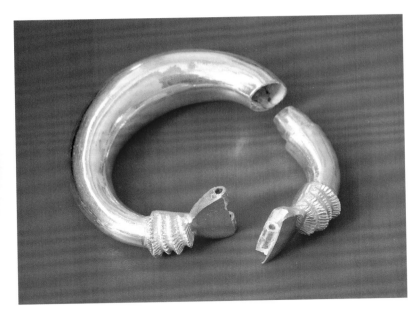

2.40 This hollow anklet made by Hanuman is of the type commissioned for the Fowler Museum in 2014 (see fig. 2.34).
PHOTOGRAPH BY THOMAS K. SELIGMAN, NOVEMBER 21, 2009.

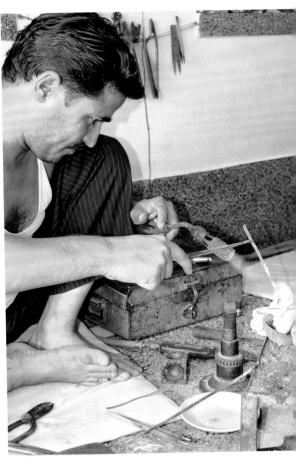

2.41 After Hanuman solders the ends onto the anklet, as shown here, the pieces are fitted together.
PHOTOGRAPH BY THOMAS K. SELIGMAN, NOVEMBER 21, 2009.

sogi that aids in melting. The melted metal is poured into an oiled steel channel to form an approximately 6 x ½ inch square ingot. The ingot is hammered on the anvil to flatten it and also to strengthen the silver. After it is somewhat flat from hammering, the silver is repeatedly put through the electric roller press so that it becomes a long flat oval sheet. Hanuman then hammers this sheet allowing the edges to curl up and touch each other. He will use a steel rod inserted into the hollow to further form the anklet until he has a long tube with tapering ends. He then trims the edges to fit each other and solders them together. Next he cools the evolving anklet in water and mixes powered limestone and water into a thick liquid that he pours into the anklet coating the inside. This is followed by pouring melted lead into the inside to give the silver support when it is hammered on a wooden block that has various curved shapes on its surface to round the anklet. If the silver does not crack, as it sometimes does, the lead is melted out of the now round silver anklet, and the limestone coating is washed off. The ends of the anklet are cast from brass prototypes in exactly the same way that solid anklets are caste. Finally, with the various pieces assembled, Hanuman fits them together soldering on the ends while allowing one part of the anklet to slot into the other so that it can be put on the wearer using a pin to hold it in place (fig. 2.41). Filing and polishing finish the anklet. The person commissioning any silver object can also request a patina that darkens the silver, which is done by applying mustard oil to the surface and then holding the piece over fire. Hanuman and his sons require about eight hours of continuous work to make a pair of these hollow anklets

The second type of object most commonly made by Hanuman and his sons is an unusual bracelet type known as *katria*, which

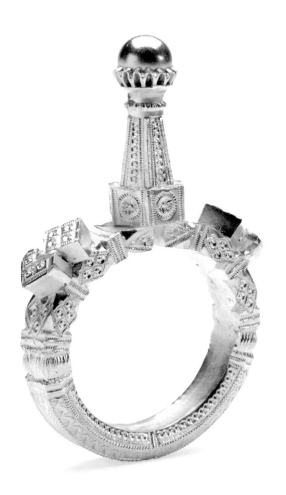

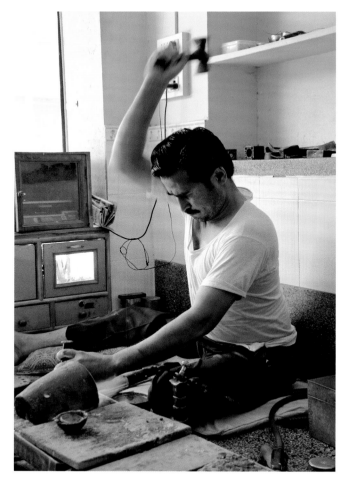

2.42
Hanuman Soni
Bracelet (*katria*), 2014
Silver
H: 10.5 cm
FOWLER MUSEUM AT UCLA X2015.2.4,
MUSEUM PURCHASE

2.43 The work performed by
Hanuman and his sons requires
significant physical strength
and effort.
PHOTOGRAPH BY THOMAS K. SELIGMAN,
JANUARY 7, 2013.

2.44 These silver bracelets, still
in progress, are part of a large
order that Hanuman and his sons
completed for a shop in the bazaar.
PHOTOGRAPH BY THOMAS K. SELIGMAN,
OCTOBER 19, 2014.

means "cutting" in the Sindi dialect (fig. 2.42). Primarily worn by Muslim women, it is made by melting 175–200 grams of silver and zinc into a slag that is then hammered and heated repeatedly until it is the desired length. While still straight, designs are cut into the silver, and the projection from the bracelet is made by casting and filing the elements and soldering them together. The silver piece is then heated and hammered around an anvil until the ends meet (fig. 2.1). Once properly aligned the protruding element is soldered onto one end covering the space between the two ends but not soldering the two ends together. This allows the bracelet to be pried open and put on the woman's wrist or upper arm above the elbow and then squeezed closed. When I was interviewing Hanuman in 2014, he, Jasraj, and Jeetu were in the process of making fifteen pairs of these bracelets for the owner of Soni Enterprise, one of the shops in the bazaar that orders from Hanuman (fig. 2.44).

Hanuman and his two oldest sons work hard and consistently, as their commissions require significant physical strength and effort (fig. 2.43). Hanuman does not consider himself an artist and does not seem at all concerned with making new or original types of jewelry. He remains rooted in his family's historic practice and has developed a good business focusing on silver ornaments for local people. In the many days I spent at his workshop, he never once had another outsider visitor. When things are slow or if he needs more money, he has developed a side business helping to market and show properties in his neighborhood that are for sale by their owners from whom he receives a small commission. Hanuman puts his life and work as a *soni* succinctly when he says that

> "To be a *soni* is to be in the act of creation. He is born into it and is a chosen one in this profession."

<div align="center">TRANSLATION BY USHA BALAKRISHNAN</div>

HARI OM JEWELLERS—ROOPKISHOR SONI

Hari Om Jewellers is one of the better-known jewelry shops in Jaisalmer. This is at least in part because it is described in the *Lonely Planet Guide to Rajasthan, Delhi & Agra* (2005, 339):

> This silversmith makes beautiful, delicate silver rings and bracelets featuring places and Hindu gods. Visitors have commissioned personalized wedding rings here and been delighted with the results. There is a shop inside the fort, or you can contact the jeweler at home: House 275, Taloti Vyaspara.

Hari Om Jewellers was established by Hari Ram Soni (circa 1925–2000). Hari Ram and his wife, Sonki Devi, first came to Jaisalmer from the Sind region of present-day Pakistan before the partition. They had nine children, the first a daughter, who is now married to a *soni*, followed by eight sons. Several of the *sonis* I had interviewed—including B. D. Soni and Dharmendra Soni—had mentioned Hari Ram and informed me that before he passed away, he was known as the best *soni* in the region. In 1989, for example, Hari Ram presented a strand of his own white hair on which he had written a Hindi verse

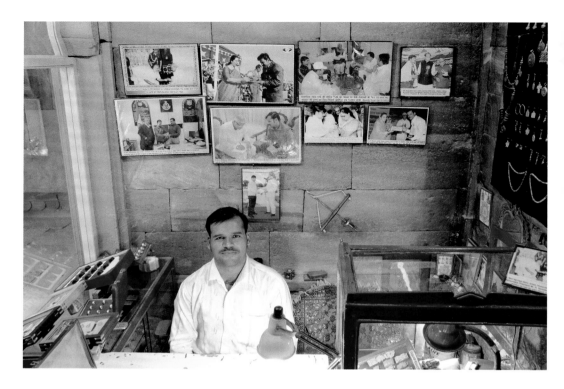

2.45 Roopkishor in the Hari
Om shop in the Rajmahal, the
maharaja's palace, within the
fort in Jaisalmer.
PHOTOGRAPH BY THOMAS K. SELIGMAN,
OCTOBER 21, 2014.

and a grain of rice on which he had drawn an image of Vishnu in
his own blood to Prime Minister V. P. Singh. Singh in turn awarded
honors to the *soni*.

In 2011 I was walking through the back streets of the fort in
Jaisalmer when I saw a sign directing visitors to the Hari Om shop
located at the south wall. Managed by one of Hari Om's very amiable
sons Raja Soni, the shop has a stock of rings, earrings, pendants, and
bracelets available for sale to tourists. After discussing the jewelry
with Raja and learning about prices and technique, I suggested that
my wife and I might like to commission rings. Roopkishor, Raja's
older brother, soon joined us, and we began our conversations.

Roopkishor is the third son of Hari Ram and Sonki Devi and was
born in Jaisalmer in 1979. He is the most skillful of all the brothers
and does the majority of the silverwork. There are two Hari Om shops
located in the fort, the one at the base of the south wall, which opened
in 1995, and a second, which opened in 2002, in the Rajmahal, the
maharaja's palace, on the eastern side of the fort overlooking the
Surya Gate. These shops are managed by five of the brothers including
Roopkishor. Indeed Roopkishor can often be found in the palace
store, where he is very eloquent and serious about telling the story of
his father (fig. 2.45). In both locations and at their large shared house
in a fairly new neighborhood away from the fort, there are color
photographic portraits of Hari Ram and Sonki Devi, both of whom
died in 2000. There are fresh flower offerings under each photo, and
there are additional images of Hari Ram receiving his award from
the prime minister. These installations have a distinct shrine-like
quality, and each evening one of the sons lights an offering of incense
under each portrait photo.

2.46 The marriage of Roopkishor Soni and his wife, Pinki, was arranged in 2012.

PHOTOGRAPH BY THOMAS K. SELIGMAN, JANUARY 7, 2013.

Hari Ram developed a distinct style of jewelry notable for relief engraving and cuts going all the way through the ornament that create specific identifiable designs, such as famous buildings, Hindu gods and goddesses, and animals. He trained his oldest son Om Parkash (b. 1974) and Roopkishor in these techniques, which Roopkishor continues to use (fig. 2.47). Although Hari Ram was admired for his artistic talents, he was not necessarily liked by other *sonis*, as they maintain that he was aloof and did not participate in activities such as pilgrimages to the Hinglaj Devi Temple or the funerals of other *sonis*. He was therefore perceived as arrogant and lived apart from the other *sonis* in Jaisalmer. His sons have inherited this reputation, and they all live together in their large house. Until 2012 none of them were married. Finally, however, an uncle arranged for four of the brothers to marry four sisters from a village distant from Jaisalmer (fig. 2.46). The wives have moved into the brothers' house in Jaisalmer, and Roopkishor and one of his brothers now each have one child.

After determining with my wife, Rita Barela, that we wanted to have Roopkishor make two rings, we discussed the design and price with him. He showed us a notebook where he has carefully recorded every ring he has made for a tourist, including the name and address and a commentary from each about what he or she wanted in the ring and the reaction to the final product. After Roopkishor completes a ring, he rubs carbon on it and rolls it across the page of the notebook to capture the design, protecting it under transparent tape. This record was of great interest because it shows the range of ideas that have been generated, as many of the rings are made for weddings or to commemorate a couple's honeymoon travels. In order to make them stronger, our commissions were not to be cut through, nor were they

2.47
Roopkishor Soni
Pendant, 2014
Silver
H: 4.5 cm
FOWLER MUSEUM AT UCLA X2015.2.10;
MUSEUM PURCHASE

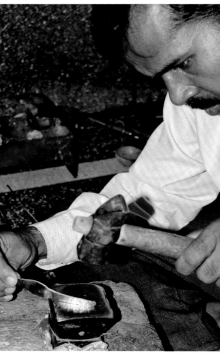

2.48 Roopkishor Soni sketches designs for a ring.
PHOTOGRAPH BY THOMAS K. SELIGMAN, OCTOBER 15, 2011.

2.49 Roopkishor Soni hammers silver to make a ring.
PHOTOGRAPH BY THOMAS K. SELIGMAN, NOVEMBER 18, 2011.

to feature the conventional buildings or animals. As we discussed the design we wanted, Roopkishor initially sketched and then finally drew it very precisely for our approval (fig. 2.48).

Documenting the making of the rings took seven days, as Roopkishor's work was continuously interrupted by his various other duties. After melting fifty grams of pure silver mixed with four grams of zinc and one gram of copper for strength, the molten metal is poured into a steel channel to make a long ingot. Hammering the ingot and cutting it in two pieces for the two rings, Roopkishor then flattens each ingot (fig. 2.49). He proceeds to make the individual rings round by heating, hammering in a steel mold with hemispherical depressions, and using pliers to complete the bending. He files the edges and gently hammers until the rings are round and are sized to fit properly.

Using an oil lamp and a tube for blowing air on the flame, Roopkishor next heats the two ends of the ring and solders them together using 80 percent silver solder mixed with flux (fig. 2.50). He weighs the two rings and the excess silver and determines that the rings weigh thirty-eight grams and that there are ten grams of excess, meaning that two grams of silver have been lost in the process of melting, hammering, and filing. This is an insignificant amount given the relatively low value of silver, but such a loss would be a major issue in working with gold due to its much higher value. This is one of the reasons that Roopkishor almost always works in silver. On occasion a tourist wants gold, and he will comply with the request only after explaining that there will be loss.

After the rings are filed smooth, he uses calipers to arrange the design on the outside of the ring sketching the design in pencil. He then engraves the design into the silver. If he were making the type

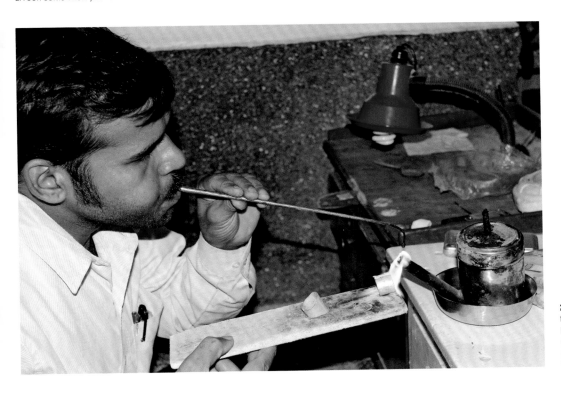

2.50 Using an oil lamp and a tube to blow air on the flame, Roopkishor solders together the ends of the ring.
PHOTOGRAPH BY THOMAS K. SELIGMAN, OCTOBER 15, 2011.

2.51a,b
Roopkishor Soni
Rings, 2012
Silver, zinc
Diam (left): 2.4 cm; (right) 2.3 cm
COLLECTION OF THOMAS K. SELIGMAN AND RITA BARELA

These rings were commissioned by the author and his wife, Rita Barela, from Roopkishor in 2011.

2.52
Roopkishor Soni
Ring, 2014
Silver
Diam: 2 cm
FOWLER MUSEUM AT UCLA X2015.2.11;
MUSEUM PURCHASE

2.53 Roopkishor examines the segments of the bracelet to be joined together for the Fowler collection.

PHOTOGRAPH BY THOMAS K. SELIGMAN,
NOVEMBER 25, 2014.

of ring that is cut all the way through, he would draw the design in pencil and drill through the ring allowing a very thin band saw to be used to cut voids into the ring. Then using an engraving tool he would add surface designs (figs. 2.51a,b).

In 2014 in the company of my colleague Usha Balakrishnan, I interviewed Roopkishor again, and he explained the pricing for his work. It takes about a month to make a complex cut-through ring in three tiers (fig. 2.52), which costs between US $250 and US $350, depending on the price of silver and the intricacy of the design. Determining to acquire some pieces for the Fowler Museum collection, we selected a bracelet of eleven squares, each with a different Hindu deity, the elements of which still needed to be joined together (figs. 2.53, 2.54), a three-tier ring (see fig. 2.52), and a pendant in the shape of India (see fig. 2.47).

When we explained to Roopkishor that these would go into the Museum's collection and would be part of an exhibition, he was extremely pleased as he believes that renown will bring prosperity. He discussed this with his older brother Om Parkash who is responsible for the family finances, and he agreed. Usha Balakrishnan and I discussed Roopkishor's goals with him, and he indicated that he wanted to be acknowledged in the *Guiness Book of World Records* for his "unique" work. As he explained to me in a video interview of October 15, 2011, "This is world famous jewelry that nobody else can do, and that is why we are in the *Lonely Planet*." He has no interest in making jewelry for local people and specializes in selling to tourists. In fact Roopkishor does not welcome other *sonis* into his shop, as he is fearful that his designs and techniques will be copied and his business undercut. In a sense, this has already happened as other

sonis know the cut-through technique, but the few examples I have seen made by others are of significantly inferior quality.

When asked why he seemed to repeat the same motifs over and over, essentially copying what his father had done or responding to the requirements of tourist commissions, Roopkishor explained that there was no time for innovation during the tourist season from September through February. During that period, he is constantly engaged in making commissions and running the palace shop. He is considering designing a zodiac ring in the coming off-season, but this is a difficult process, as the images have to fit the circumference of the ring exactly, and many sketches and measurements are necessary. Roopkishor seemed to believe that the excellent workmanship on the current designs was enough to generate many sales and would keep him fully occupied making new stock for the shops in the off-season. Roopkishor most definitely sees himself as an artist. He is currently teaching two of his younger brothers to make jewelry like that his father designed. He reminds them as well of their father's fame and the honor of being included in the *Lonely Planet* guide. ℰ

2.54
Roopkishor Soni
Bracelet, 2014
Silver
L: 17.5 cm
FOWLER MUSEUM AT UCLA X2015.2.9;
MUSEUM PURCHASE

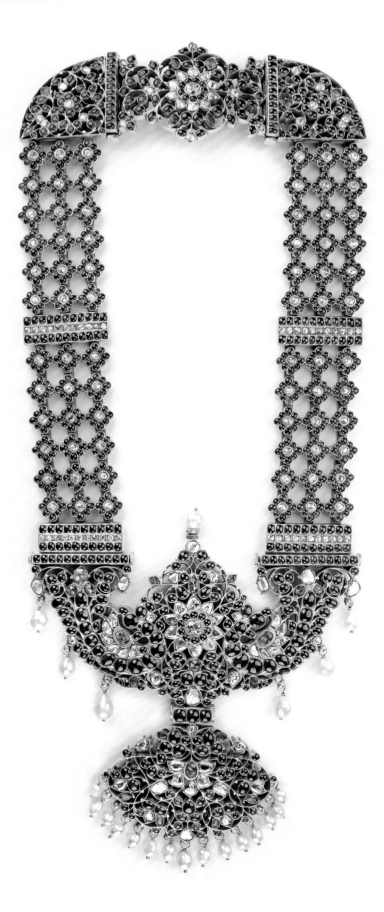

3

PURE SERENDIPITY: AN ODYSSEY INTO THE WORLD OF INDIAN JEWELRY

Usha R. Balakrishnan

*The most profound enchantment for the collector is the locking of
individual items within a magic circle in which they are fixed as
the final thrill, the thrill of acquisition, passes over them.*

WALTER BENJAMIN

ON MARCH 22, 1990, as Ronald and Maxine Linde flipped through the
pages of a Sotheby's auction catalog of Indian, Himalayan, and
Southeast Asian Art, a magnificent necklace caught their eyes (fig.
3.1). It was like nothing they had ever seen before. Three rows of
ruby and diamond flowers formed a chain suspending an elaborate
fan-shaped pendant surmounted by two stylized, addorsed peacocks
in a garden of foliage—all set with cabochon rubies, diamonds, and
emeralds. The necklace had an elaborate clasp at the back with a
trelliswork of gem-set floral motifs. In a matter of minutes the neck-
lace was locked "within a magic circle."[1]

> We loved it and were fascinated by the splendor of it! The
> sale was being held on March 21 and 22, and we started
> lamenting not having discovered the piece sooner so as
> to have the opportunity to bid on it. We then looked at our
> watches and realized that the sale might still be going on.
> We picked up the phone and called Sotheby's. They had not
> quite come to that lot yet; so we placed a maximum absentee
> bid a little above the high estimate and won the lot at exactly
> our maximum bid. When the necklace arrived, it exceeded
> all our expectations. After we had the time to learn more
> about the art of Indian jewelry, we ventured forth when
> other opportunities arose and ultimately became aggressive
> collectors of the jewelry and jeweled arts of India.[2]

The thrill of discovery that began that day marked the commencement
of an odyssey for the Lindes, and twenty-seven years later they still
continue on their journey.

Chairman and president, respectively, of The Ronald and Maxine
Linde Foundation—a private foundation they established in 1989—
the Lindes have supported numerous philanthropic endeavors aimed
at benefiting science and humanity. While they have spent decades
engaged in business and entrepreneurship, their art collection has

3.1
Necklace (*makarakanthi*)
Tamil Nadu, nineteenth century
Gold, diamonds, rubies, emeralds,
 pearls
L: 40 cm
RONALD AND MAXINE LINDE COLLECTION, PROMISED
GIFT OF RONALD AND MAXINE LINDE, 10248
NOT IN EXHIBITION
PHOTO BY LEILA KELLY

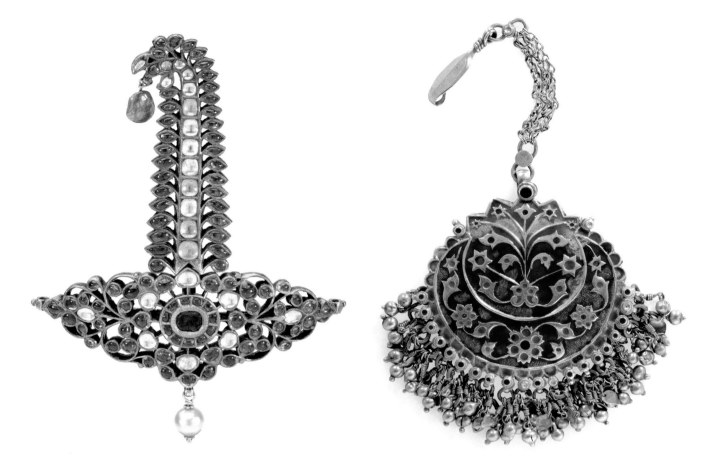

3.2
Turban ornament (*kalgi*)
South India, nineteenth century
Gold, rubies, white sapphires,
 pearls
11.4 x 10.2 cm
RONALD AND MAXINE LINDE COLLECTION, PROMISED
GIFT OF RONALD AND MAXINE LINDE, 10991

3.3
Head ornament (*chiri tikka*)
Himachal Pradesh, nineteenth
 century
Silver, enamel
L: 23.5 cm (including the chain)
RONALD AND MAXINE LINDE COLLECTION, PROMISED
GIFT OF RONALD AND MAXINE LINDE, 17884

served to counterbalance their highly analytical temperaments. A scientist-artist himself, Ron's modern sculptures appear on the grounds surrounding their facilities. These works are constructed with mathematical precision and reveal multiple allusions and illusions as the viewer perceives them. The sense of harmony that Ron and Maxine Linde find in art and science also finds expression in their almost otherworldly, state-of-the-art home, which is designed as a large parallelogram and set in the middle of a hauntingly beautiful desert landscape. Given their choice of setting, it seems appropriate that the first major exhibition of Indian jewelry from their promised gift to UCLA should appear in *Enduring Splendor: The Jewelry of India's Thar Desert*.

The Linde Collection demonstrates great breadth, depth, and diversity. It includes miniature bangles and crowns no more than an inch high made to adorn tiny statues of gods and goddesses; fabulous jeweled accoutrements crafted for temple deities; bejeweled plumes, set with cabochon rubies, diamonds, and emeralds, and once tucked into the turbans of maharajas (fig. 3.2); and stunning necklaces, crafted from gold and set with diamonds, which in times past proclaimed the wealth of the merchants who wore them (fig. 3.4). Head ornaments, necklaces, earrings, bangles, bracelets, and anklets—crafted from gold, encrusted with gemstones, engraved with fine designs, and exquisitely enameled on the reverse—are, moreover, displayed side-by-side

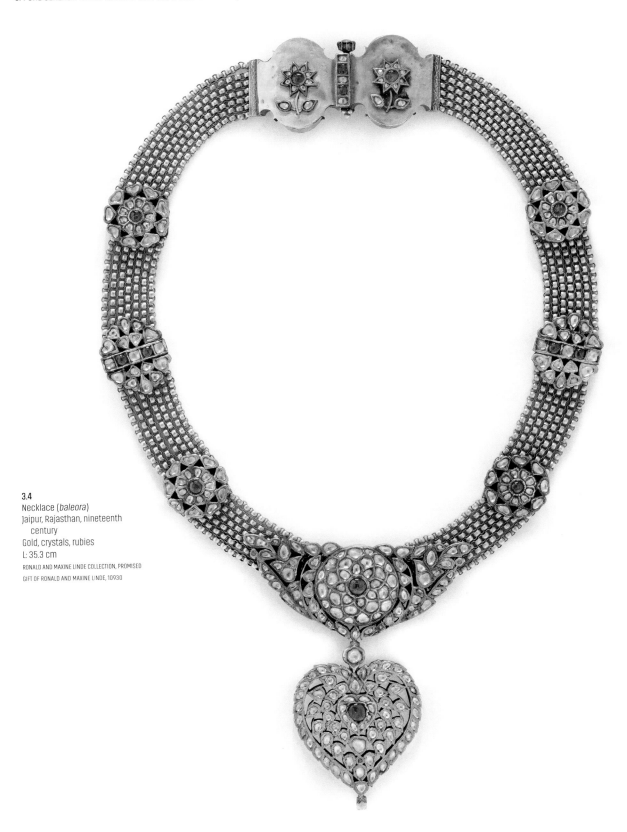

3.4
Necklace (*baleora*)
Jaipur, Rajasthan, nineteenth
 century
Gold, crystals, rubies
L: 35.3 cm
RONALD AND MAXINE LINDE COLLECTION, PROMISED
GIFT OF RONALD AND MAXINE LINDE, 10930

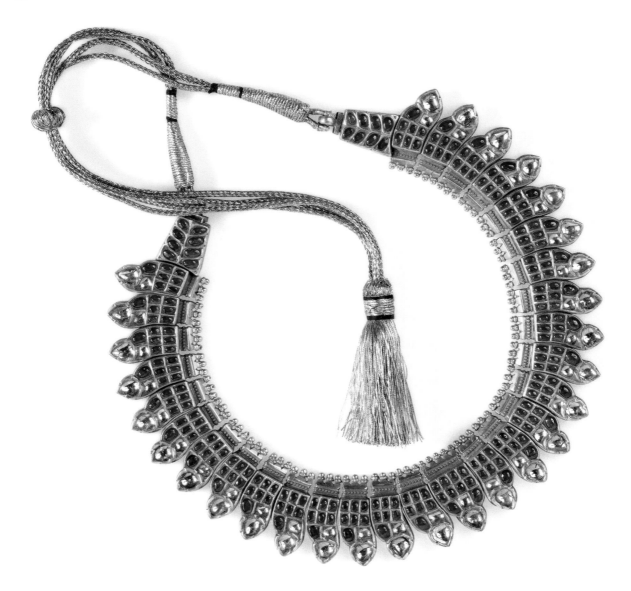

3.5
Necklace (*nagapada tali*)
Kerala, nineteenth century
Gold, diamonds, rubies
L: 32 cm

with hundreds of items of silver jewelry in organic and strikingly modern abstract forms that belie the simplicity of the rural and tribal communities they represent.

The collection is without parallel in the world, being private and comprehensive and spanning the vast Indian Subcontinent. A silver-enameled forehead jewel from the hills of Himachal Pradesh (fig. 3.3) in the north, a necklace simulating cobra hoods from Kerala in South India (fig. 3.5), gem-encrusted ornaments and minimalist silver jewelry from the western state of Gujarat (fig. 3.6), and a sinister-looking brass trophy-head necklace that displays the head-hunting prowess of a Konyak warrior from Nagaland in the northeast exemplify the panoramic sweep of the collection.

Jewelry, beads, and gemstones were once traded along the Silk Road, and tales of the wealth and gem bazaars of India circulated throughout the ancient world. As a result, the collecting of Indian

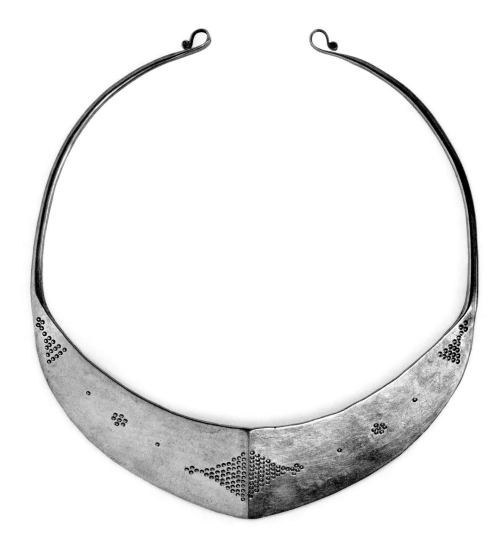

jewelry has a deep history. Many peoples were first exposed to this jewelry in the Thar—the Great Indian Desert that encompasses Gujarat and Rajasthan, stretches across the province of Sind in Pakistan, and extends to the banks of the Indus River.

It was in Mohenjo Daro, the ancient city of the Indus Valley civilization, located on the westernmost periphery of the Thar, that archaeologists discovered the "most important find of the (1925–1926) season."[3] This magnificent jewelry hoard included gold earrings, more than ten forehead fillets (headbands), silver bangles, silver finger rings, and beads. Made of steatite, faience, gold, silver, and semiprecious hard stones, beads were found in "hundreds of thousands…in a wide array of types and materials, each requiring its own manufacturing technology."[4] Lapis lazuli, chalcedony, carnelian, chrysoprase, jade, jasper, onyx—the variety and volume of materials used in the industry were unparalleled at the time (see fig. 1.5).

3.6
Necklace (*hansadi*)
Kutch, Gujarat, early twentieth century
Silver
L: 22 cm
RONALD AND MAXINE LINDE COLLECTION, PROMISED GIFT OF RONALD AND MAXINE LINDE, 12840

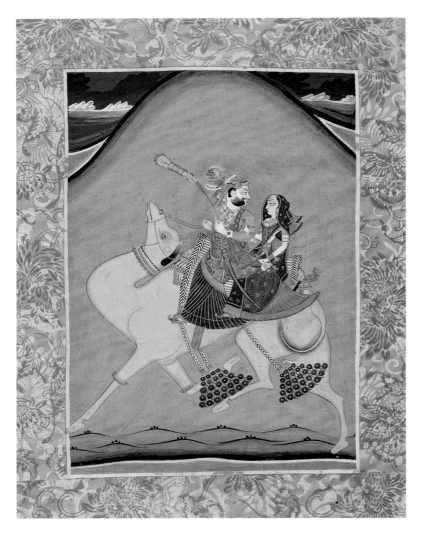

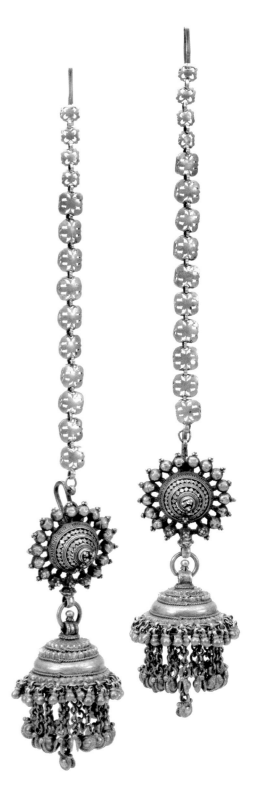

3.7
Dhola and Maru on a Camel
Jodhpur, Marwar, Rajasthan,
 circa 1830
Opaque watercolor and gold on
 paper
Image: 31.43 x 21.59 cm; Sheet:
 40.32 x 29.85 cm

LOS ANGELES COUNTY MUSEUM OF ART, INDIAN ART
SPECIAL PURPOSE FUND, M.75.59.1

3.8
Earrings (*karanphul jhumka*)
Rajasthan, nineteenth century
Silver
L: 31.5 cm

RONALD AND MAXINE LINDE COLLECTION, PROMISED
GIFT OF RONALD AND MAXINE LINDE, 15544

3.9
Bracelets (*gajre*)
Gujarat, late nineteenth century
Silver
Diam: 9 cm
RONALD AND MAXINE LINDE COLLECTION, PROMISED
GIFT OF RONALD AND MAXINE LINDE, 12693

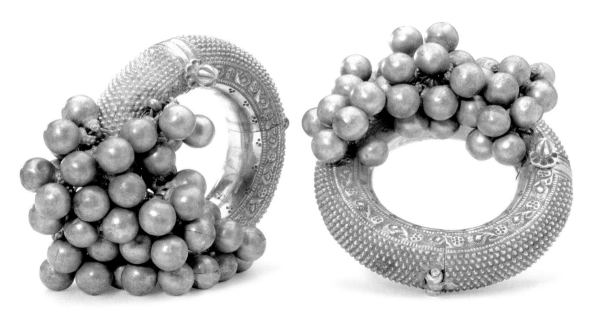

India was the bead-manufacturing center of antiquity, and Indian-made beads were exported to the Near East, Mesopotamia, Egypt, Greece, Rome, and Southeast Asia. Beads are a quintessential component of most Indian jewelry. Even emeralds, rubies, and spinels were tumbled into beads and strung along with pearls into fabulous necklaces, turban jewels, and arm ornaments (as can be seen in the jewelry worn by Prince Dhola and Princess Maru in a nineteenth-century miniature painting from Rajasthan [fig. 3.7]). In a pair of ornate silver earrings (fig. 3.8), beads border flower heads, decorate the edge of the bell-shaped forms, and are suspended below like tassels. Hollow beads simulate woven jasmine buds on bracelets (fig. 3.9), and clusters of silver balls are arranged around the opening of anklets (fig. 3.10).

3.10
Anklets (*kalla*)
Rajasthan, nineteenth century
Silver
Diam: 13.3 cm
RONALD AND MAXINE LINDE COLLECTION, PROMISED
GIFT OF RONALD AND MAXINE LINDE, 15860

Foreign monarchs Mahmud of Ghazni (r. circa 1000–1027) and Nadir Shah (r. 1736–1747), and Alauddin Khilji (r. 1296–1316), ruler of the Delhi Sultanate, all made forays into various parts of India and in the process carted away vast quantities of gold, gems, jewelry, and jeweled objects. Among the items plundered from the Mughal treasury by Nadir Shah in 1739 were Shah Jahan's gem-encrusted Peacock Throne, which was melted down, and the magnificent Kohinoor diamond, which currently forms part of the British Crown Jewels. In addition, camel loads of gold ingots and trunks filled with diamonds, rubies, emeralds, and pearls were transported to Iran. While much of the loot was used to fund wars and bribe enemies, remnants of the pillage still repose in the National Treasury in the Central Bank of Iran in Tehran. Some of the fabulous jeweled objects from India were brought to the Russian court by ambassadors of Nadir Shah in 1741 and presented to Empress Elizaveta Petrovna. Today these gifts are on exhibition in the State Hermitage Museum in Saint Petersburg.

In the eighteenth and nineteenth centuries, items of Indian jewelry were also collected as novelties and carefully preserved in kunstkammers, or cabinets of curiosities, throughout Europe. The cabinet belonging to William V (1748–1806), Prince of Orange, included a collection of Indian jewelry assembled by Julius van Gollenesse, the director-general of the Dutch East India Company in Surat, Gujarat. The collection is presently housed in the Rijksmuseum, Amsterdam. The Victoria and Albert Museum and the British Museum in London hold pieces of Indian jewelry that were acquired following the Great Exhibitions of the nineteenth century, which were organized to showcase the wealth of the Empire. India, the "Jewel in the British Crown," was represented in these exhibitions by various manufactures, including gold and silver ornaments. Fabulous items are also in the possession of the Museum of Islamic Art in Doha, Qatar, and select pieces of Indian jewelry feature in the collections of other museums in England, Europe, and the United States.

In 1990, however, when the Lindes started acquiring pieces, few private collections of Indian jewelry existed. At the time, interest in the field was confined to Mughal-period "masterpieces" and gold jewelry set with gemstones. Among the few large private collections of this genre in the world, the Al Sabah collection in Kuwait and the Khalili and Al Thani collections in London are the most notable. Few collectors were interested in silver jewelry. Silver was the metal of the poor and not considered worthy of collecting. Kings and queens did not wear silver necklaces, bangles, and earrings; and silver jewelry did not epitomize royalty, wealth, and romance. The beauty of the jewelry of rural communities was, nonetheless, recognized as early as 1881–1882 in "The Punjab Exhibition Report," which notes, "to many eyes, some of these [silver items] might appear barbaric, but they possessed a character and quality of design previously wanting in more pretentious work."[5] In recent decades, the Colette and Jean-Pierre Ghysels collection in Brussels and the René van der Star collection in the Netherlands have helped to introduce the world to the beauty of ethnic silver jewelry from India.

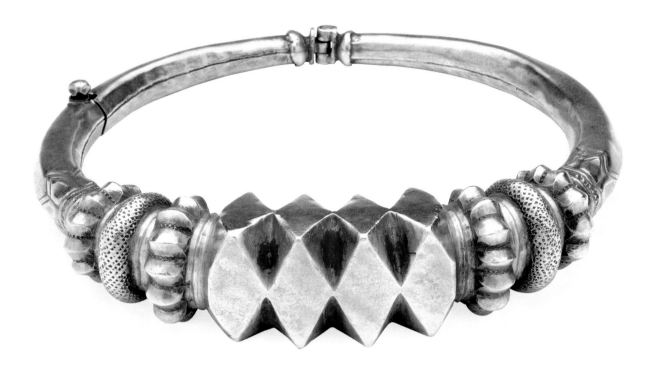

3.11
Necklace (*hansuli*)
Rajasthan, early twentieth
century
Silver
L: 14 cm
RONALD AND MAXINE LINDE COLLECTION, PROMISED
GIFT OF RONALD AND MAXINE LINDE, 12829

For the Lindes, however, all Indian jewelry, whether made of gold, silver, or any other material, has always been "transcendent." They do not collect from an investment standpoint and clearly state, "Although we are cognizant of the value of a piece, our primary motivation is assembling a body of work that provides an understanding and history of the region." They emphasize, "Our main interest always has been in the art, the craftsmanship, and the historical context. Therefore, we have been resistant to buying very expensive pieces where a predominant portion of the price is based on the value of the stones themselves." Justifying their love for rural silver ornaments, Ron explains, "Both our backgrounds are steeped in scholarship. Hence the focus is not just on masterpieces or on any particular period but is oriented toward broader scholarship." Their philosophy of collecting is aimed at "documenting history, understanding the cultures that created the objects, honoring the craftsmen who wrought them, and acknowledging the patrons who sustained the art form over millennia." Ultimately, it is their hope that the jewelry will facilitate a "greater understanding of the people associated with [its] creation."

Although the Lindes have never traveled to India, their longstanding fascination with and study of Indian jewelry has in effect taken them across the length and breadth of the country. They have explored numerous ethnographic contexts in depth and analyzed designs imbued with the symbolism of varied religions, beliefs, and cultures. Significantly, they have never failed to consider the *soni* in the course of their research. Indeed, as Walter Benjamin writes in

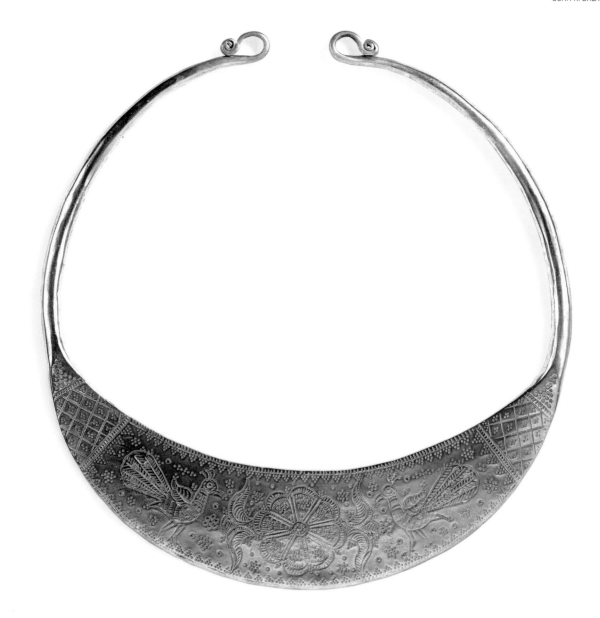

3.12
Necklace (*hansadi*)
Gujarat, early twentieth century
Silver
L: 24 cm

Illuminations, "the period, the region, the craftsmanship, the former ownership—for a true collector the whole background of an item adds up to a magic encyclopedia whose quintessence is the fate of his object."[8]

An item of jewelry begins life as a lump of metal in the workshop of the *soni*. *Sonis* worked in royal ateliers and made jewelry for maharajas and their favorite gods. Their customers were wealthy merchants in the towns and cities but also poor farmers of the countryside and villages. There were no goldsmithing schools, nor were there technical manuals. Knowledge and skills were acquired by observing grandfathers, fathers and uncles; by performing small tasks under supervision; and by repetitive practice. Workshops were small and family run, and they were usually located in the front

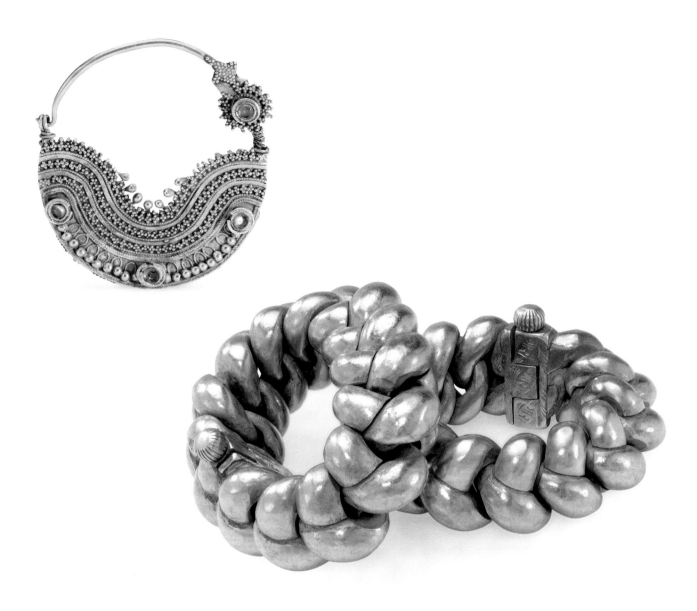

3.13
Nose ring (*nathadi*)
Gujarat, late eighteenth to early
nineteenth century
Gold, topaz
5.1 x 4.4 cm
RONALD AND MAXINE LINDE COLLECTION, PROMISED
GIFT OF RONALD AND MAXINE LINDE, 11800

3.14
Anklets (*sankhla*)
Gujarat, late nineteenth century
Silver
Diam: 12.5 cm
RONALD AND MAXINE LINDE COLLECTION, PROMISED
GIFT OF RONALD AND MAXINE LINDE, 12662

room of the home, overlooking the street, while the family resided in the back. Specialization in the various stages of manufacture, such as casting, repoussé work, gem setting, enameling, and so on, were all nurtured within the family.

The vast repertoire of techniques that craftsmen used to shape metals into ornaments is well represented in the Linde collection. While one solid silver necklace, for example (fig. 3.11), was made using the sand-casting process, another elegant torque (fig. 3.12) was created by hammering silver into a thick sheet, cutting out the form, and then engraving peacocks and flowers on the surface with sharp tools. A nose ring (fig. 3.13) is intricately decorated with minute gold granules, and extremely sophisticated repoussé work is conspicuous in the fine detail on an amulet (see fig. 1.12). The unknown smith who

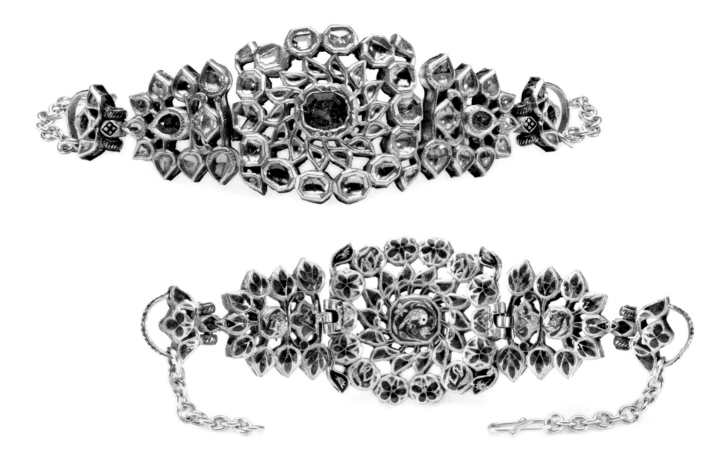

3.15a,b
Front (top) and back (bottom)
views of an armband (*bazuband*)
Jaipur, Rajasthan, nineteenth
century
Gold, diamonds, emeralds, enamel
3.7 x 10.5 cm
RONALD AND MAXINE LINDE COLLECTION, PROMISED
GIFT OF RONALD AND MAXINE LINDE, 15739

made of a pair of anklets known as *sankhla* (fig. 3.14) used cire perdue, or lost-wax casting, to fashion this amazingly flexible set. The gem setter embedded precious and semiprecious stones within ribbons of pure gold, and the enameler formed cavities and filled them with vibrant colors (figs. 3.15, 3.16). While the preferred metal for setting precious gemstones was gold, silver was usually set with synthetic stones and foil-backed glass to simulate real gems.[7]

Large quantities of silver ornaments are rarely held as stock-in-trade by the *soni*. Silver pieces are handcrafted one at a time, mostly on commission, and the weight of the ornament is carefully calibrated to individual specifications depending on the budget. Each silver necklace, bracelet, and anklet is therefore unique with slight variations in proportion, symmetry, contour, and decorative details. It is this raw and sometimes unfinished appearance, as seen in a pair of twisted wire earrings (fig. 3.17), that constitutes the quintessential charm of rural jewelry.

Ananda Coomaraswamy, the renowned philosopher-historian of Indian art remarked that "the best things are always well rooted in the soil."[8] Nowhere is this more evident than in the beautiful organic and geometric forms and decorative motifs inspired by nature that figure so prominently in Indian jewelry. The feathers of a heron,

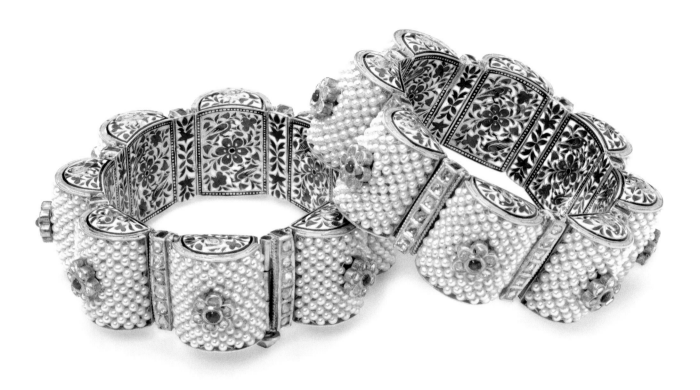

3.16
Bracelets (*gajre*)
Bikaner, Rajasthan, nineteenth
 century
Gold, diamonds, pearls, enamel
Diam: 8.3 cm
RONALD AND MAXINE LINDE COLLECTION, PROMISED
GIFT OF RONALD AND MAXINE LINDE, 16070

3.17
Earrings (*nagali*)
Gujarat, early twentieth century
Silver
L: 7.6 and 8 cm
RONALD AND MAXINE LINDE COLLECTION, PROMISED
GIFT OF RONALD AND MAXINE LINDE, 12909

3.18
Anklets (*kadla*)
Gujarat, early twentieth century
Silver
Diam: 8 cm
RONALD AND MAXINE LINDE COLLECTION, PROMISED
GIFT OF RONALD AND MAXINE LINDE, 12665

shells, jasmine buds, chrysanthemum flowers, and all manner of flora and fauna, including marine forms such as shells (fig. 3.18), are stylized in objects of adornment and decorative motifs. While the simple contours and restrained elegance of some of the items are in keeping with the unpretentious lifestyle of village communities, the drama and flamboyance of others, including a pair of bracelets with stylized flower buds around the edge (fig. 3.19), appear to be at variance with such a spare existence.

Jewelry forms have remained intact, evolved, moved across geographical regions, and transformed through exposure to myriad influences. The necklace, earrings, and armband adorning an eleventh-century androgynous image of Shiva and Parvati (fig. 3.21) are mirrored in a necklace from Kerala (see fig. 3.5), a pair of earrings from Gujarat (fig. 3.20), and an armband from Tamil Nadu (fig. 3.22). This despite the fact that more than eight hundred years and one thousand miles separate the sculpture and the jewelry. Continuity in jewelry designs can also be seen in a stylized eighteenth-century portrait of the bejeweled Mughal empress Nur Jahan (fig. 3.23). Her earrings, armband, and bangle are remarkably similar to pieces in

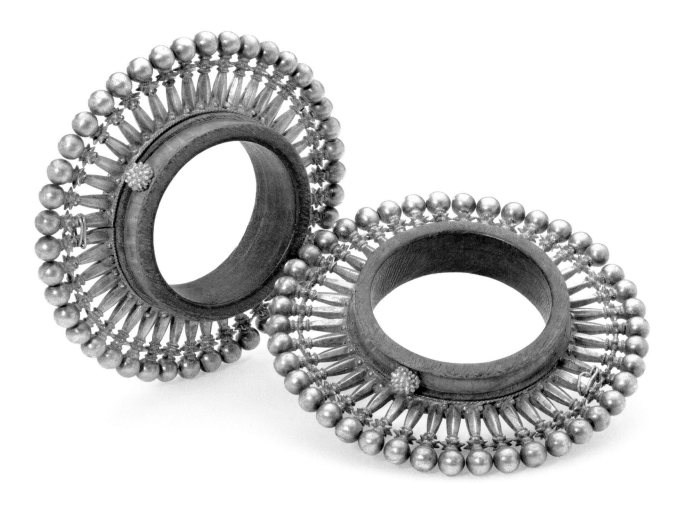

the Linde collection (figs. 3.24–3.26). While many jewelry forms have remained the same over centuries, the origin and antiquity of others remain shrouded in mystery.

The Lindes' eye for the beautiful and unusual, coupled with their admiration for the *soni's* ability, has informed their collecting in many ways. This is evident in a pair of massive anklets in the form of a flower in full bloom (fig. 3.27). The centerpiece, which resembles the petals of the flower, is strikingly plain and curved to fit comfortably around the ankle, while the hoop is elaborately decorated with applied silver protrusions—evoking the vine to which the flower must have clung. The result is a testimony to the genius of ideation and craftsmanship.

Many of the silver jewelry forms that appear in this volume are still worn by peoples in the Thar Desert region. While every group, community, and caste has its own unique cultural identity, religion, and customs, the appeal of jewelry is universal, and it has long served as a safe haven for accumulated wealth. Nose rings have been used to signify marital status, and the images of gods and goddesses stamped on silver have provided protection against the evil eye (fig. 3.28).

3.19
Bangles (*kada*)
Rajasthan, nineteenth century
Silver, wood
Diam: 13 cm
RONALD AND MAXINE LINDE COLLECTION, PROMISED GIFT OF RONALD AND MAXINE LINDE, 15547

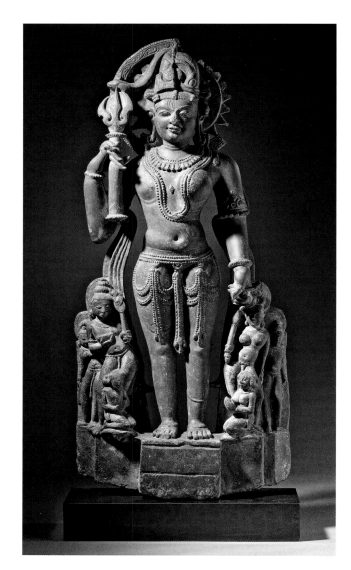

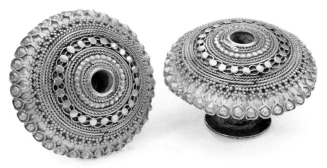

3.20
Earrings (*bhungri*)
Gujarat, early twentieth century
Gold
Diam: 3.5 cm

3.22
Armband (*nagothu*)
Tamil Nadu, nineteenth century
Gold, rubies, white sapphires
H: 1.8 cm; Diam: 7 cm

3.21
The Androgynous Form of Shiva
 and Parvati (Ardhanarishvara)
Rajasthan, eleventh century
Black schist
62.86 x 29.21 x 9.52 cm

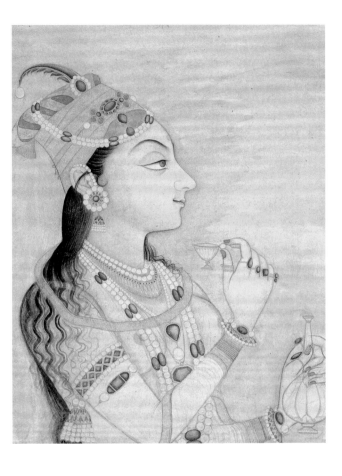

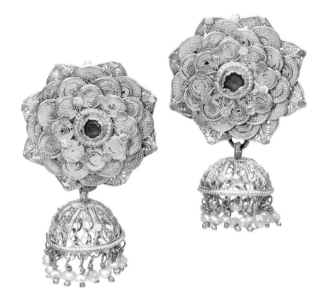

3.23
Idealized Portrait of the Mughal
　Empress Nur Jahan (1577–1645)?
Kishnagarh, Rajasthan, circa
　1725–1750
Opaque watercolor and gold
　on paper
29.52 x 21.59 cm
LOS ANGELES COUNTY MUSEUM OF ART, GIFT
OF DIANDRA AND MICHAEL DOUGLAS, M.81.271.7

3.24
Earrings (*karanphul jhikka*)
Orissa, late nineteenth century
Gold, rubies, pearls
2.5 × 3.6 cm
RONALD AND MAXINE LINDE COLLECTION, PROMISED
GIFT OF RONALD AND MAXINE LINDE, 11362

3.25a,b
Front (top) and back (bottom)
　views of an armband (*bazuband*)
North India, late seventeenth to
　early eighteenth century
Gold, jade, diamonds, rubies
3 x 7 cm
RONALD AND MAXINE LINDE COLLECTION, PROMISED
GIFT OF RONALD AND MAXINE LINDE, 12213

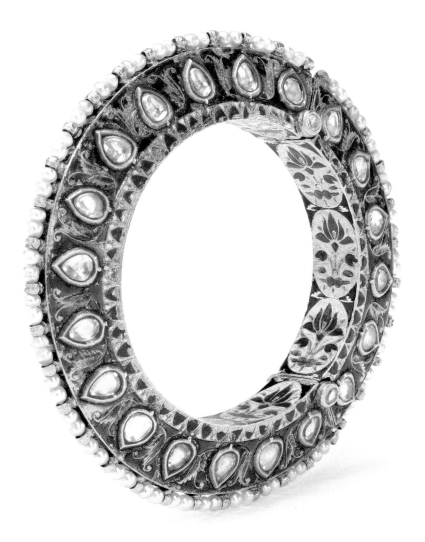

3.26
Bracelet (*kada*)
Deccan, eighteenth century
Gold, white sapphires, pearls,
 enamel
Diam: 8 cm
RONALD AND MAXINE LINDE COLLECTION, PROMISED
GIFT OF RONALD AND MAXINE LINDE, 15735

Necklaces identified community, and items of jewelry functioned as visual symbols of the societal power of the individual and of the hierarchy within a family. Women wore jewelry from head to toe (fig. 3.29), the pieces carefully positioned on pressure points located along energy pathways, or *nadis*, in the body. Points on the forehead, the earlobe, the base of the neck, the wrist, and so on, are activated by the weight of the jewel, releasing a flow of energy that contributes to physical and emotional good health.

Over time, the manifold original meanings and connotations of abstract motifs have become blurred, lost in transmission, and set aside as a consequence of changed lifestyles. Even the craftsmen are no longer cognizant of these symbolic codes, merely adhering to long-established designs and motifs and replicating them with mechanical precision. While the abstract form of the torque made by Hanuman Soni (see fig. 2.33) with its solid cuboid centerpiece might look contemporary, minimalist, and unusual, the genesis of its long-standing design is lost forever. The striking design of pieces like this one allows them to transcend time.

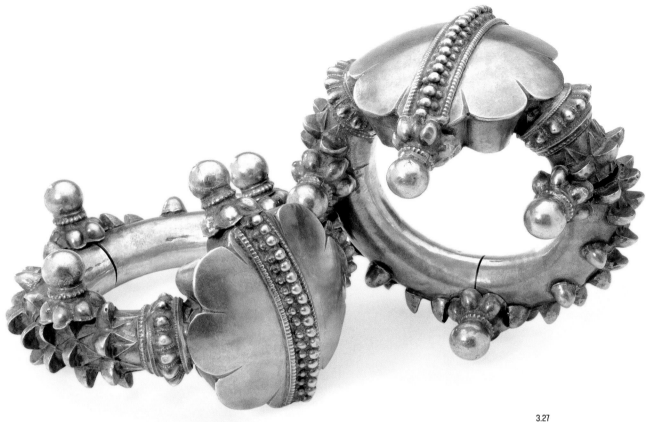

3.27
Anklets (*kadla*)
Gujarat, early nineteenth century
Silver
Diam: 11.5 cm
RONALD AND MAXINE LINDE COLLECTION, PROMISED
GIFT OF RONALD AND MAXINE LINDE, 15271

3.28
Amulet pendant (*madaliya* or
 chhedi ka jantar)
Rajasthan, nineteenth century
Silver, polychrome paint, glass
8.5 x 8 cm
RONALD AND MAXINE LINDE COLLECTION, PROMISED
GIFT OF RONALD AND MAXINE LINDE, 16045

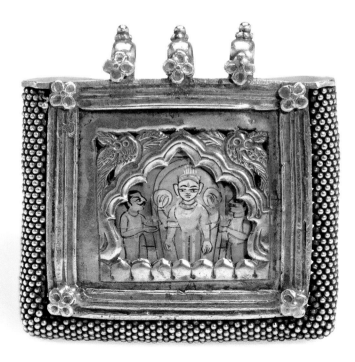

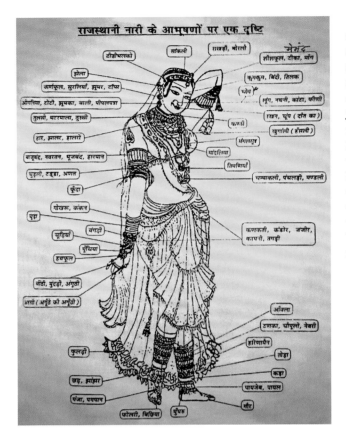

3.29 A drawn diagram indicates the range and variety for all the pieces of traditional jewelry worn by a Rajasthani woman. It also gives the names of the individual pieces.
PRIVATE COLLECTION.

The Linde collection has been assembled from a wide variety of sources—auction houses, dealers from around the world, and private families. The collection has grown organically so that every piece of jewelry occupies its own unique niche and creates a powerful dialogue with its fellows and with the viewer. With the knowledge they have acquired over almost three decades, the purchase of a piece of jewelry today is more intellectual for the Lindes than impulsive. While Ron is more likely to be persuaded to buy a newly discovered piece because of a nuanced difference from others in the collection, Maxine would be more inclined to await something with a more-decided difference.

The challenge for them now is to position each potential acquisition in the context of their already comprehensive collection and to evaluate its significance and its quality. If the new piece is better but overlaps with something they already have, then the earlier acquisition can be deaccessioned. It is all about the disciplined excitement of the hunt for truly meaningful additions, the exhilaration of the pursuit, and ultimately the satisfaction of a successful acquisition. The acquired jewelry joins a "safe haven," as it were. Many items have been saved from the melting crucibles to which they are habitually consigned, the only recourse for a poor farmer during hard times when he has to provide for his family.

The Lindes' aim in assembling an encyclopedic compendium of Indian jewelry is nurtured by the hope that their collection will help to shape the study of Indian jewelry—allowing future generations of scholars and purveyors of fashion and beauty to appreciate and study the genius of these unique handcrafted works. This is beautifully articulated by Ron and Maxine, who note, "While collecting gives us immense personal joy, it is by ultimately sharing the collection that we will derive the most satisfaction—knowing that, at least indirectly, we can help to inculcate understanding, admiration, respect, and awe for these exquisitely crafted objects, the cultures they represent, the people who caused them to be made, and the craftsmen who created them." By deciding to donate their private collection to UCLA, where it will be housed with the Fowler Museum, the Lindes desire that "understanding of the art of Indian jewelry should not be viewed merely from the perspective of the art of India—but rather in the context of the political, economic, and cultural history of the period in which every single item is positioned."

It is fitting that the Lindes have promised their private collection to a major research university where faculty and students across disciplines can benefit from this stellar record of artistic creativity and technical accomplishment. Their choice of UCLA and the Fowler was not prompted primarily by the fact that both Ron and Maxine are alumni of UCLA, but was motivated largely by their "accord with the UCLA/Fowler mission to enhance interdisciplinary understanding and appreciation of human cultures in different parts of the world and the dedication and probity of the UCLA/Fowler team."

The Lindes are confident that their collection will be brought meaningfully into the public domain through the Museum's outstanding exhibition, publication, research, and teaching programs.

NOTES

1. Walter Benjamin, *Illuminations*, ed. Hannah Arendt, trans. Harry Zohn (New York: Schocken, 1986), 60.
2. I was introduced to Ronald and Maxine Linde in 1995 when I was working on my first book on Indian jewelry, *Dance of the Peacock: Jewellery Traditions of India*. I, too, had fallen in love with the necklace in the 1990 Sotheby's catalog and sought their permission to include the piece in my book. They not only immediately agreed, but also generously shared other beautiful items from their collection acquired during the intervening years. Since then, our mutual fascination with the subject has remained unabated. This essay is based on conversations and e-mail communications with Ronald and Maxine Linde over many beautiful years of warm friendship.
3. Gregory L. Possehl, *The Indus Civilization: A Contemporary Perspective* (Walnut Creek, CA: Altamira, Rowman & Littlefield, 2002), 202.
4. Possehl (see note 3, above), 95.
5. Thomas Holbein Hendley, *Indian Jewellery*, reprint ed. (Delhi: Low Price Publications, 1995), 49.
6. Benjamin (see note 1, above), 60.
7. In recent times CAD/CAD (Computer Aided Design and Computer Aided Manufacturing) processes and machines have been introduced to mass-produce gold jewelry as well as jewelry set with gemstones.
8. Alvin Moore and Rama P. Coomaraswamy, *Selected Letters of Ananda K. Coomaraswamy* (Delhi: Indira Gandhi National Center for the Arts and Oxford University Press, 1988), 372.

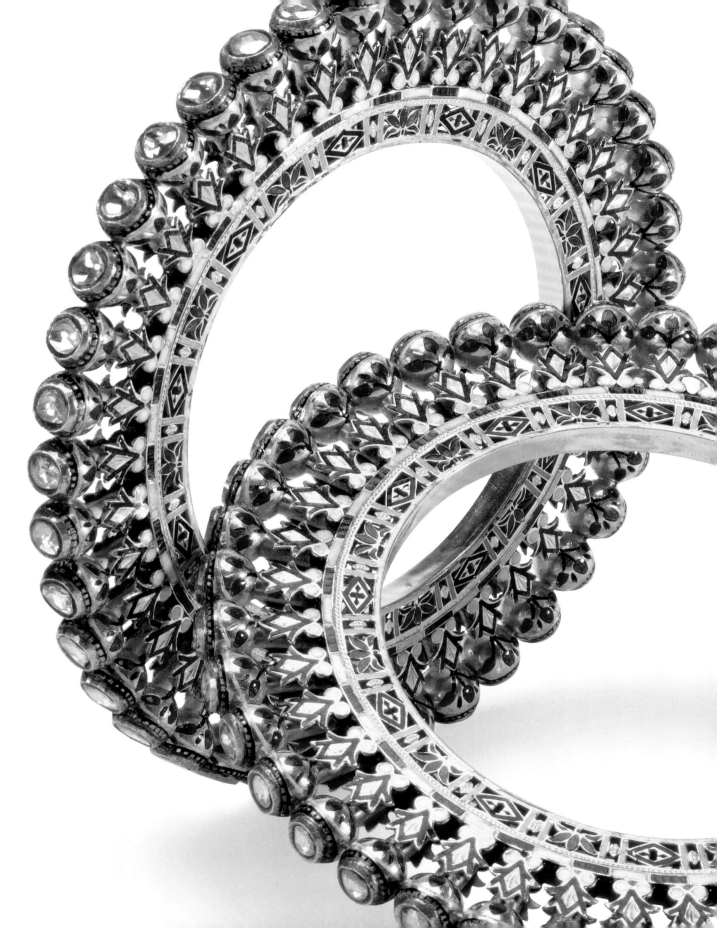

SELECTIONS FROM THE RONALD AND MAXINE LINDE COLLECTION OF JEWELRY AND RITUAL ARTS OF INDIA

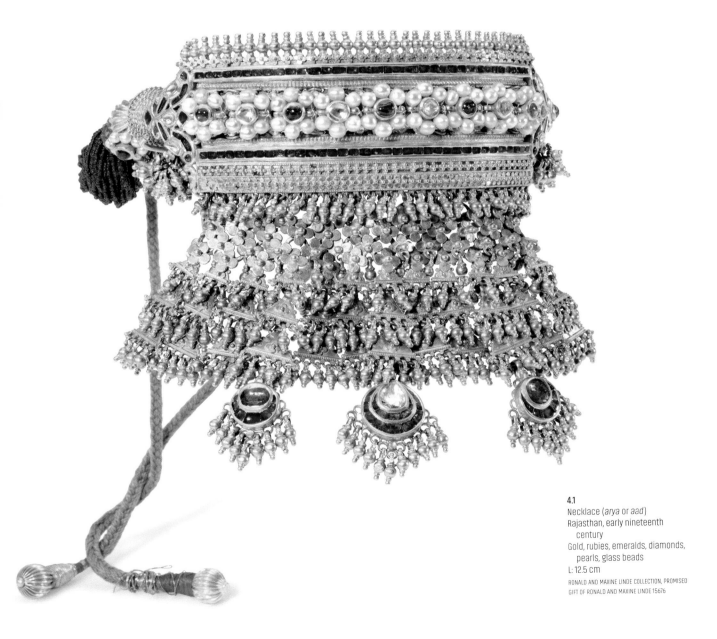

4.1
Necklace (*arya* or *aad*)
Rajasthan, early nineteenth
 century
Gold, rubies, emeralds, diamonds,
 pearls, glass beads
L: 12.5 cm

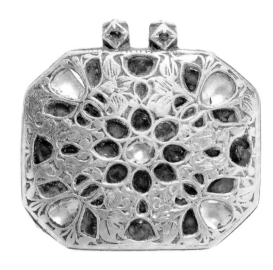

4.2a,b
Front (left) and back (right) of an
 amulet pendant (*ta'wiz*)
Mysore, Karnataka, sixteenth to
 seventeenth century
Gold, emeralds, rubies, diamonds
6 x 8.5 cm

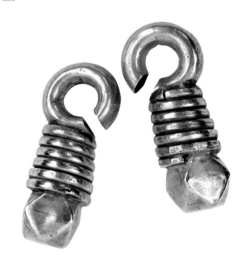

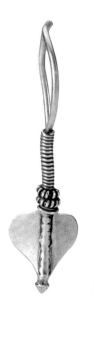

4.3
Earrings (*vedhla*)
Gujarat, twentieth century
Silver
L: 5.7 cm

4.4
Earrings (*ognia* or *pipalpanna*)
Rajasthan, nineteenth to
 twentieth century
Silver
L: 5 cm

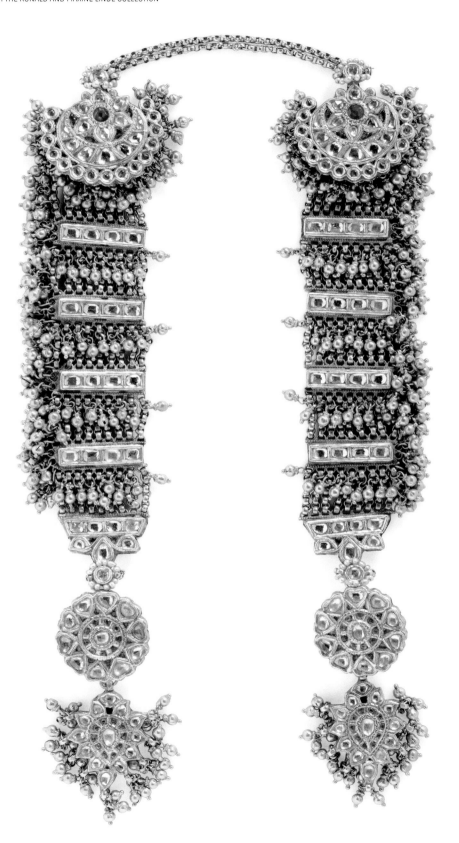

4.5
Earrings (*jhela-jhumra*)
Rajasthan, late eighteenth to
 early nineteenth century
Gold, diamonds, rubies, emeralds
L: 22.5 cm

RONALD AND MAXINE LINDE COLLECTION, PROMISED
GIFT OF RONALD AND MAXINE LINDE 12186

4.6
Earrings (*nagali*)
Gujarat, late nineteenth to early
 twentieth century
Silver
L: 6.8 cm

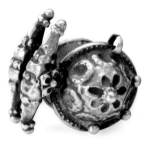

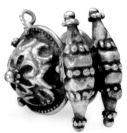

4.7
Earrings (*akota*)
Rajasthan, early twentieth century
Silver
L: 3.2 cm

4.8
Earrings (*akota*)
Gujarat, late nineteenth to early
 twentieth century
Silver
L: 8 cm

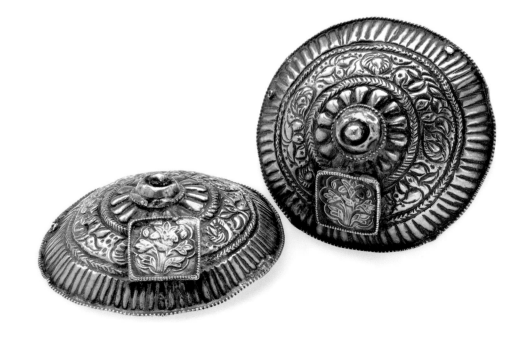

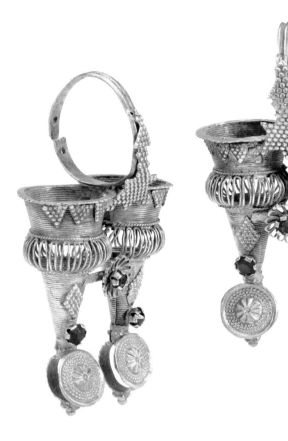

4.9
Earrings (*nagali*)
Gujarat, early twentieth century
Gold, glass
L: 8.3 cm
RONALD AND MAXINE LINDE COLLECTION, PROMISED
GIFT OF RONALD AND MAXINE LINDE 12931

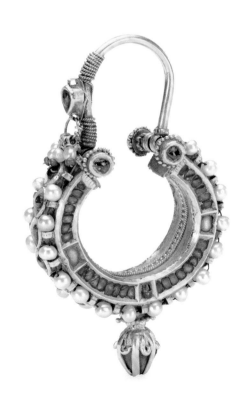

4.10
Earring (*bawaria*)
Rajasthan, circa eighteenth
 century
Gold, rubies, diamonds, emeralds,
 pearls
L: 7 cm
RONALD AND MAXINE LINDE COLLECTION, PROMISED
GIFT OF RONALD AND MAXINE LINDE 11879

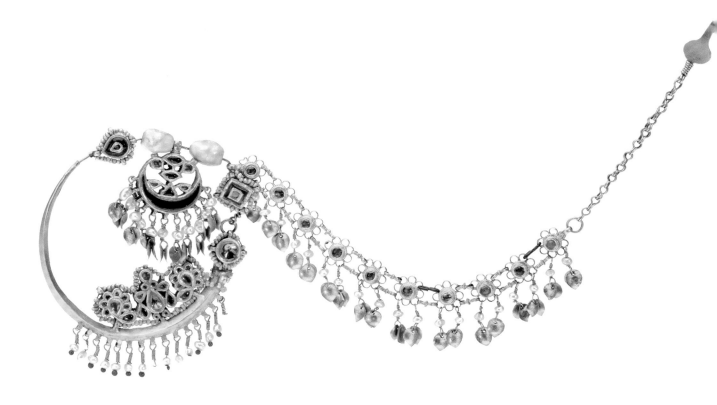

4.11
Nose ring (*nath*)
Rajasthan, early nineteenth century
Gold, rock crystals, spinels,
emeralds, turquoise, pearls
6.5 x 21 cm
RONALD AND MAXINE LINDE COLLECTION, PROMISED
GIFT OF RONALD AND MAXINE LINDE 12576

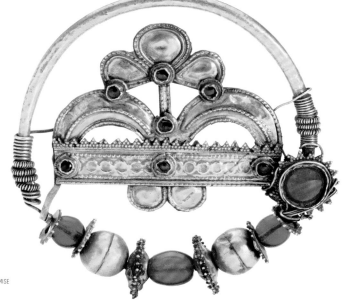

4.12
Nose ring (*nath*)
Gujarat, nineteenth century
Gold, glass, pearls
6.6 x 7 cm
RONALD AND MAXINE LINDE COLLECTION, PROMISE
GIFT OF RONALD AND MAXINE LINDE 12517

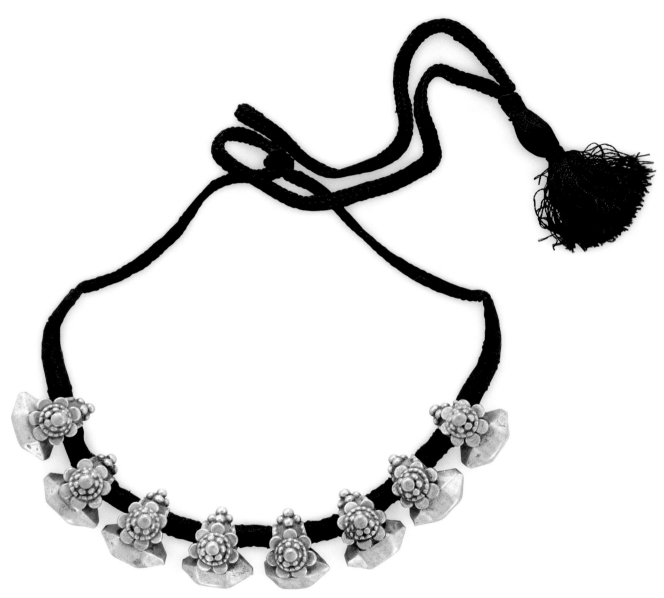

4.13
Necklace (*champakali har*)
Orissa, early twentieth century
Silver
Beads (each): 2.4 × 2.5 cm

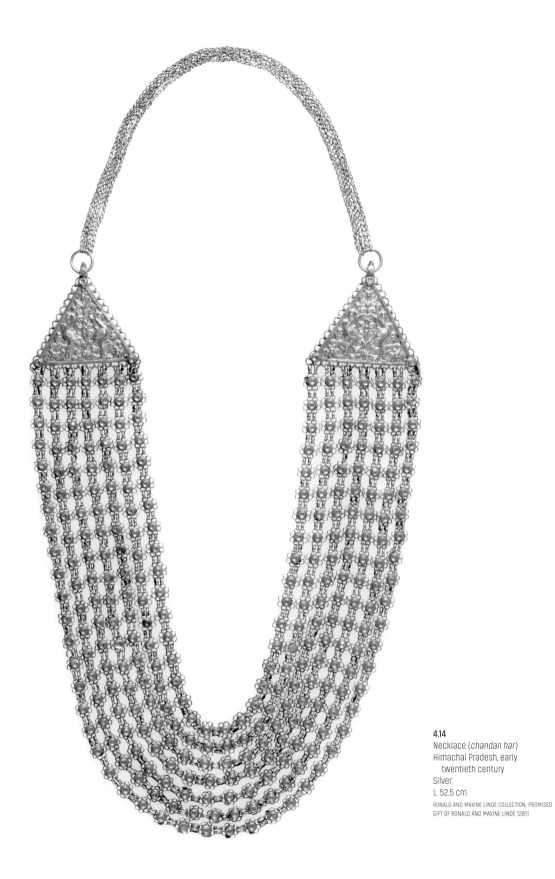

4.14
Necklace (*chandan har*)
Himachal Pradesh, early
 twentieth century
Silver
L: 52.5 cm

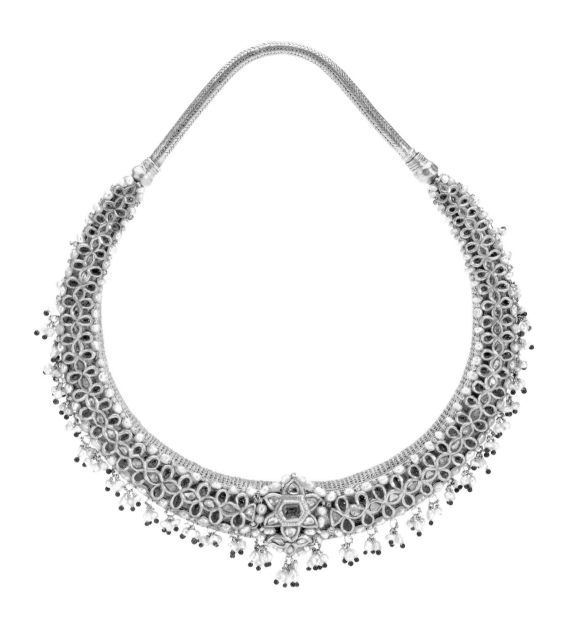

4.15
Necklace (*hasli*)
Rajasthan, early nineteenth
 century
Gold, diamonds, emeralds, pearls
L: 18.2 cm

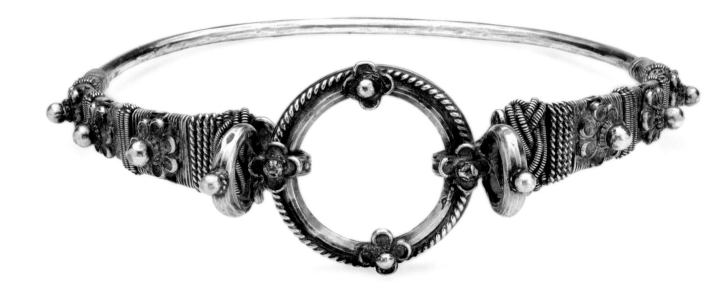

4.16
Necklace (*vadlo*)
Rajasthan, early twentieth
 century
Silver
L: 21.5 cm

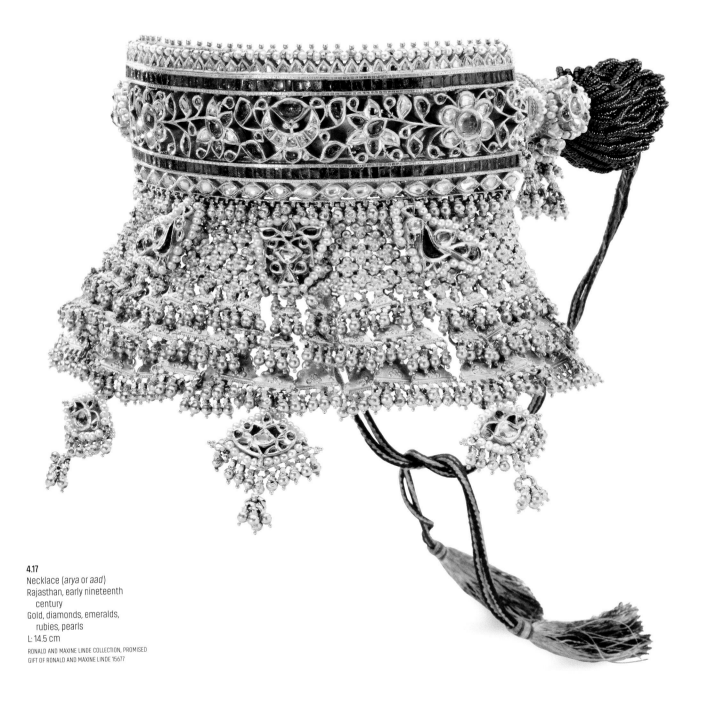

4.17
Necklace (*arya* or *aad*)
Rajasthan, early nineteenth
 century
Gold, diamonds, emeralds,
 rubies, pearls
L: 14.5 cm

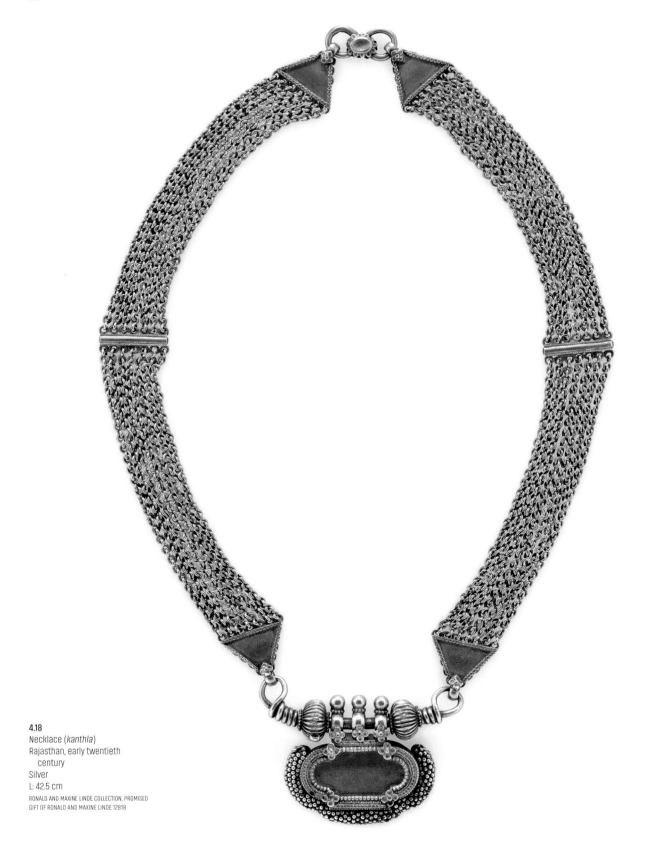

4.18
Necklace (*kanthla*)
Rajasthan, early twentieth
 century
Silver
L: 42.5 cm

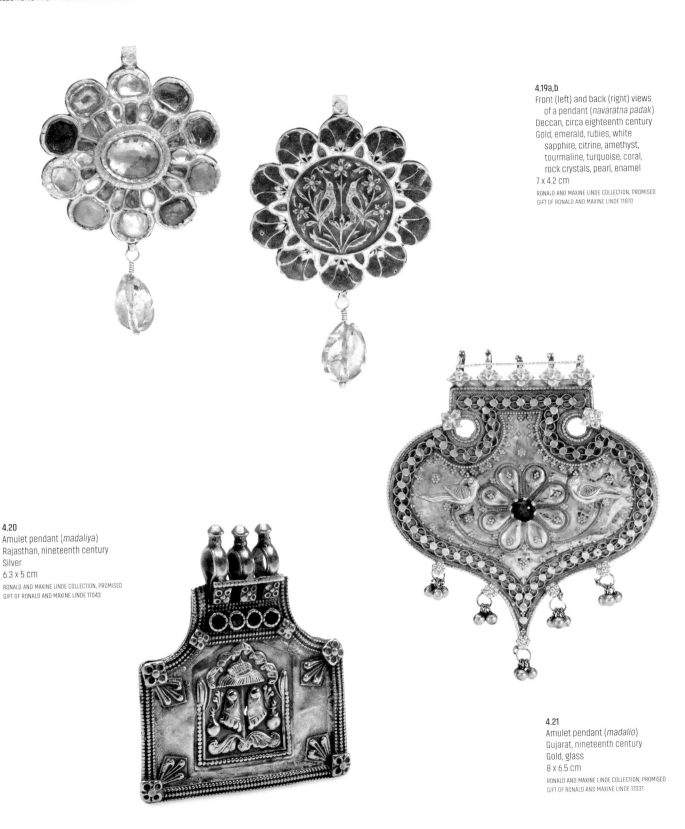

4.19a,b
Front (left) and back (right) views
 of a pendant (*navaratna padak*)
Deccan, circa eighteenth century
Gold, emerald, rubies, white
 sapphire, citrine, amethyst,
 tourmaline, turquoise, coral,
 rock crystals, pearl, enamel
7 x 4.2 cm
RONALD AND MAXINE LINDE COLLECTION, PROMISED
GIFT OF RONALD AND MAXINE LINDE 11870

4.20
Amulet pendant (*madaliya*)
Rajasthan, nineteenth century
Silver
6.3 x 5 cm
RONALD AND MAXINE LINDE COLLECTION, PROMISED
GIFT OF RONALD AND MAXINE LINDE 17043

4.21
Amulet pendant (*madalio*)
Gujarat, nineteenth century
Gold, glass
8 x 6.5 cm
RONALD AND MAXINE LINDE COLLECTION, PROMISED
GIFT OF RONALD AND MAXINE LINDE 17031

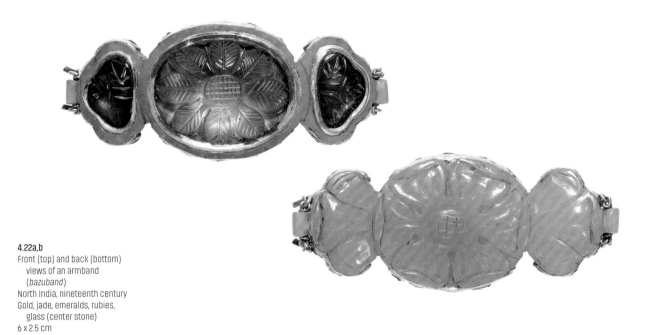

4.22a,b
Front (top) and back (bottom)
 views of an armband
 (*bazuband*)
North India, nineteenth century
Gold, jade, emeralds, rubies,
 glass (center stone)
6 x 2.5 cm
RONALD AND MAXINE LINDE COLLECTION, PROMISED
GIFT OF RONALD AND MAXINE LINDE 16464

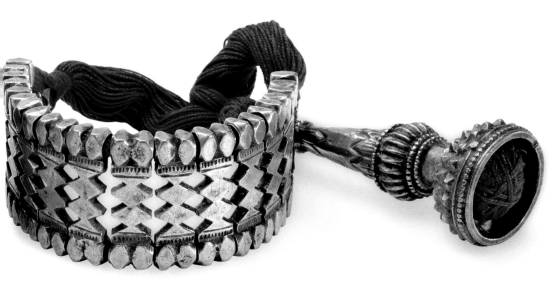

4.23
Armbands (*bazuband*)
Deccan, early eighteenth century
Silver, tourmalines, enamel
4 x 10 cm

The armband at the top is shown
from the front, and the one at the
bottom is shown from the back.

4.24
Armbands (*bazuband*)
Rajasthan, early twentieth
 century
Silver
4 x 19 cm

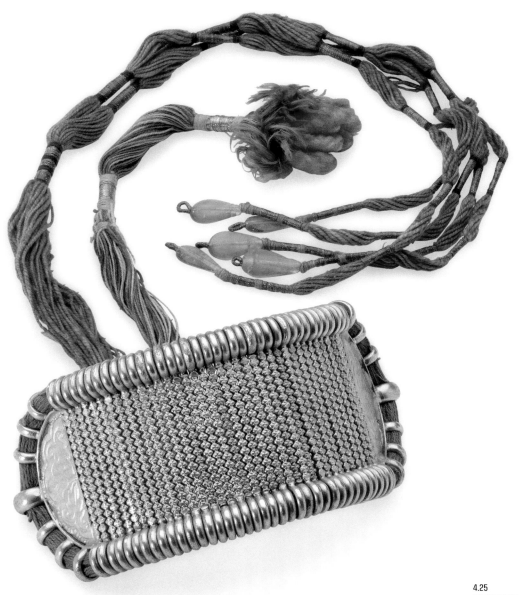

4.25
Armband (*bazuband or bahutta*)
Rajasthan, nineteenth century
Silver
6 x 12.7 cm

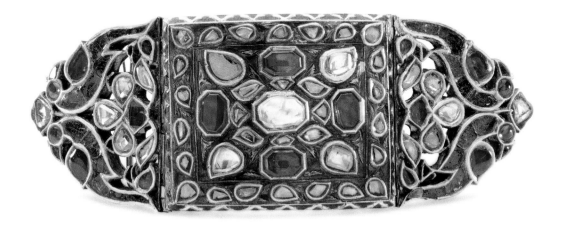

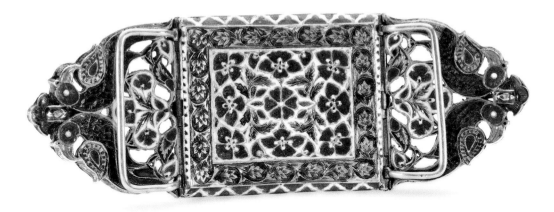

4.26a,b
Front (top) and back (bottom)
 views of an armband
 (*bazuband*)
Rajasthan, India, late eighteenth
 century
Gold, diamonds, rubies, emeralds,
 enamel
3.5 x 9.5 cm

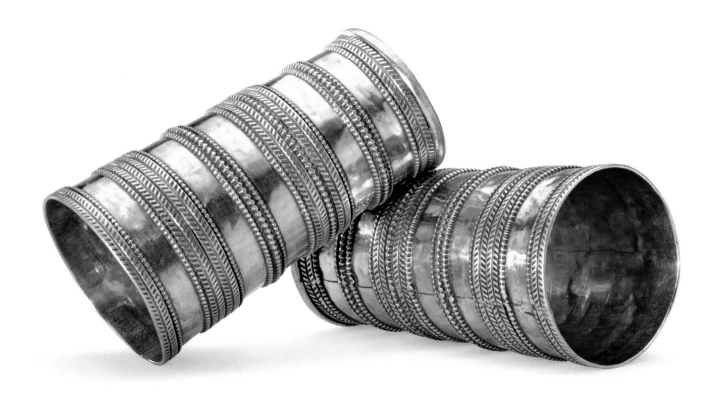

4.27
Upper arm/forearm bracelets
 (*chood*)
Rajasthan, early twentieth century
Silver
L: 15.6 cm

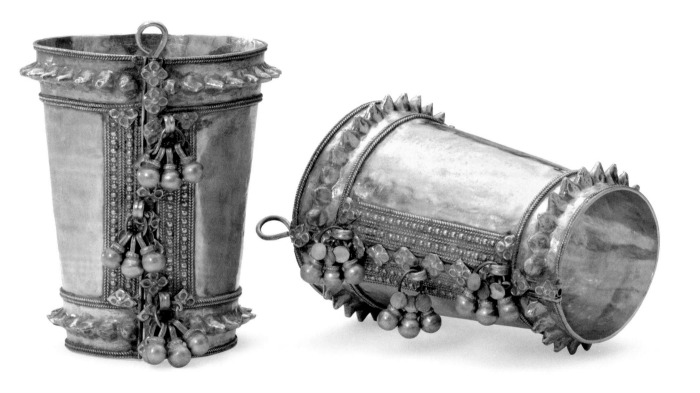

4.28
Bracelets (*chood* or *kadla*)
Gujarat, nineteenth century
Silver
L: 10 cm

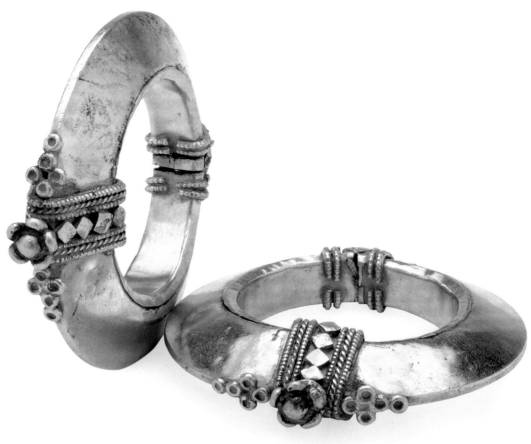

4.29
Bracelets (*balé*)
Karnataka, late nineteenth century
Silver
Diam: 9 cm

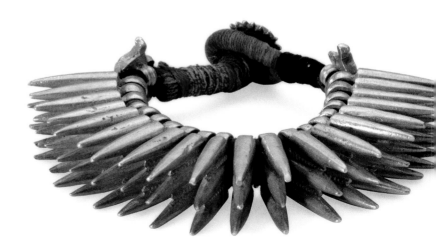

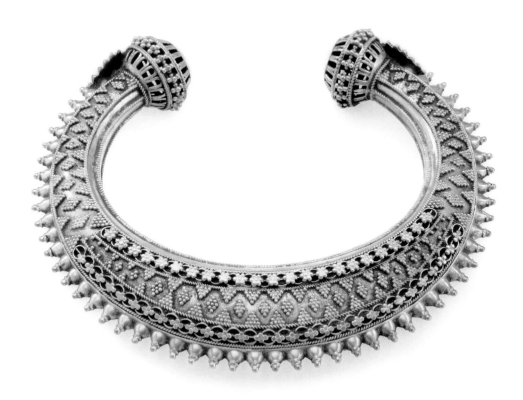

4.30
Bracelet (*kara*)
Rajasthan/Gujarat, circa
 nineteenth century
Gold
Diam: 8.9 cm
RONALD AND MAXINE LINDE COLLECTION, PROMISED
GIFT OF RONALD AND MAXINE LINDE 10855

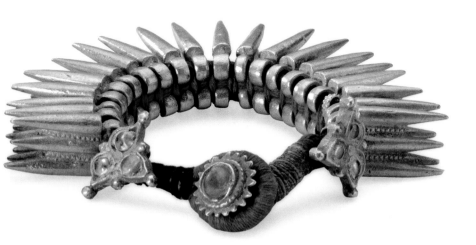

4.31
Bracelets (*pahunchian*)
Rajasthan, nineteenth century
Silver
Diam: 9.1 cm
RONALD AND MAXINE LINDE COLLECTION, PROMISED
GIFT OF RONALD AND MAXINE LINDE 12600

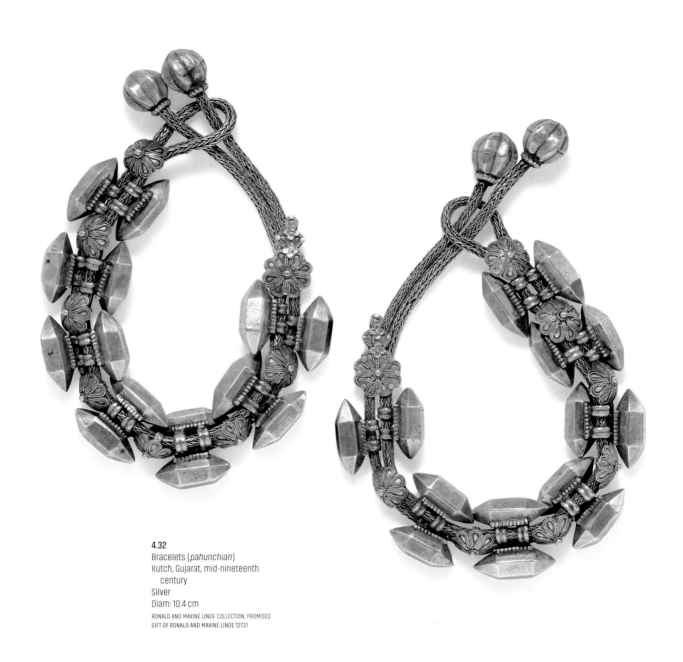

4.32
Bracelets (*pahunchian*)
Kutch, Gujarat, mid-nineteenth
 century
Silver
Diam: 10.4 cm

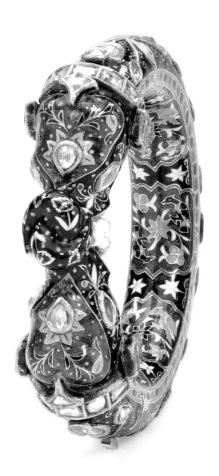
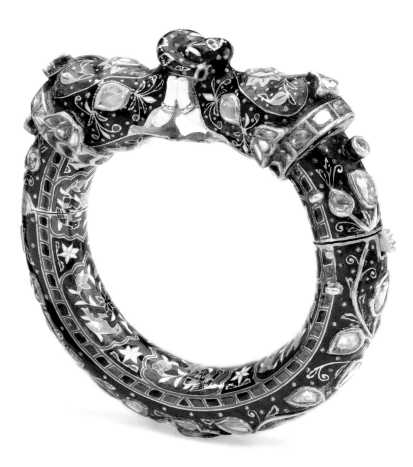

4.33
Bangles (*kada*)
Jaipur, Rajasthan, circa 1900
Gold, diamonds, cat's eye,
 turquoise, enamel
Diam: 9.9 cm
RONALD AND MAXINE LINDE COLLECTION, PROMISED
GIFT OF RONALD AND MAXINE LINDE 16072

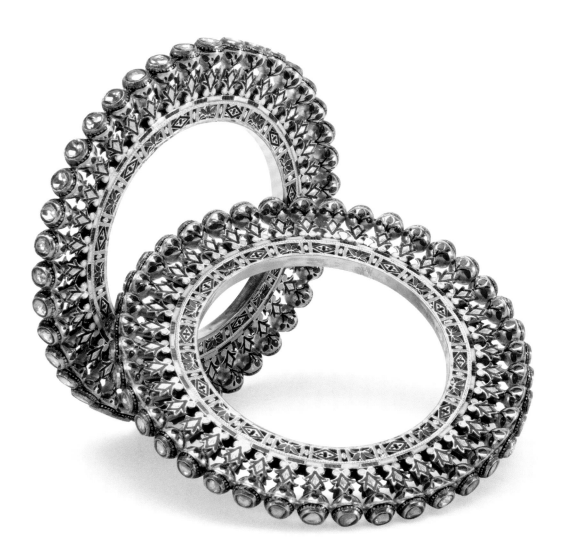

4.34
Bangles (*gokhru*)
Rajasthan, circa eighteenth
 century
Gold, diamonds, enamel
Diam: 11.4 cm
RONALD AND MAXINE LINDE COLLECTION, PROMISED
GIFT OF RONALD AND MAXINE LINDE 10803

4.35
Hand ornament (*haathphul*)
Rajasthan, late nineteenth century
Gold, white sapphires, enamel
L: 15.2 cm
RONALD AND MAXINE LINDE COLLECTION, PROMISED
GIFT OF RONALD AND MAXINE LINDE 10957

4.36
Hand ornament (*haathphul*)
Rajasthan, nineteenth century
Silver
L: 28.5 cm
RONALD AND MAXINE LINDE COLLECTION, PROMISED
GIFT OF RONALD AND MAXINE LINDE 16304

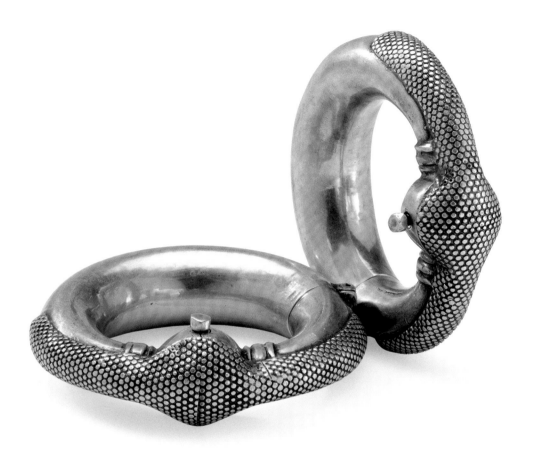

4.37
Anklets (*kara*)
Gujarat, early twentieth century
Silver
Diam: 10 cm

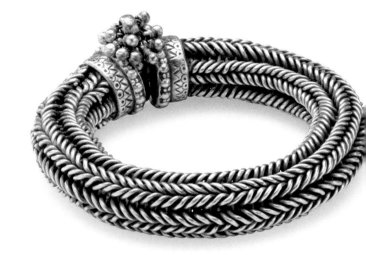

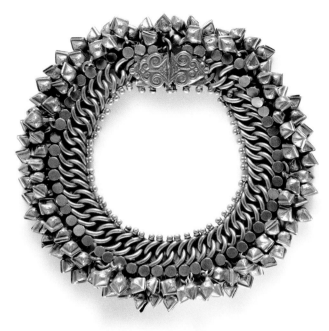

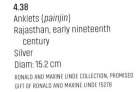

4.38
Anklets (*painjin*)
Rajasthan, early nineteenth
 century
Silver
Diam: 15.2 cm
RONALD AND MAXINE LINDE COLLECTION, PROMISED
GIFT OF RONALD AND MAXINE LINDE 15278

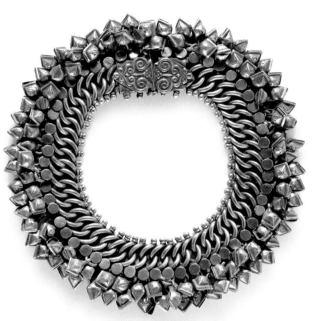

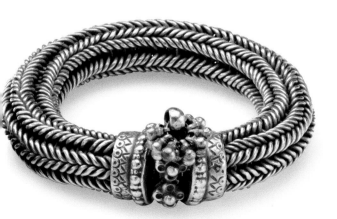

4.39
Anklets (*bala*)
Rajasthan, early twentieth century
Silver
Diam: 10.9 cm
RONALD AND MAXINE LINDE COLLECTION, PROMISED
GIFT OF RONALD AND MAXINE LINDE, 12635

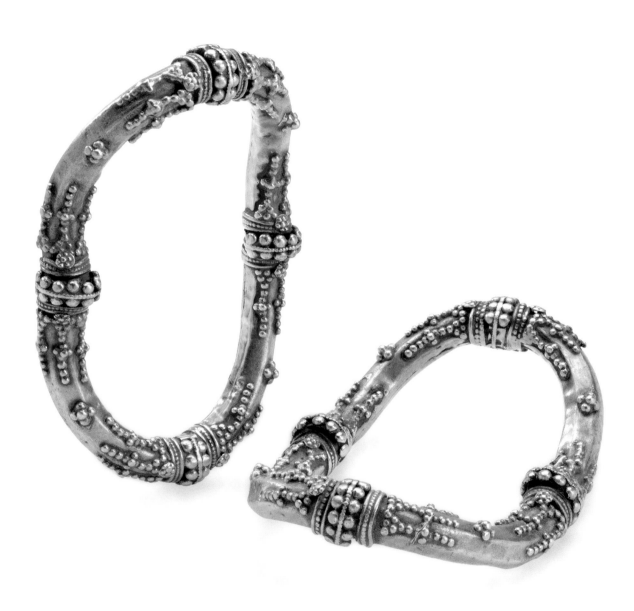

4.40
Anklets (*goda bala*)
Orissa, mid-nineteenth century
Silver
14.1 x 9 cm

4.41
Toe Ring (*viti*)
Gujarat, twentieth century
Silver
3.5 x 3.2 cm
RONALD AND MAXINE LINDE COLLECTION, PROMISED
GIFT OF RONALD AND MAXINE LINDE 16305

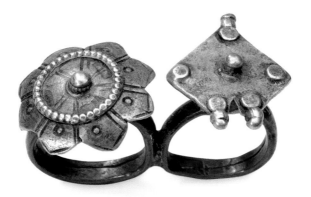

4.42
Toe Ring (*damo*)
Gujarat, early twentieth century
 to mid-twentieth century
Silver, copper
3 x 5 cm
RONALD AND MAXINE LINDE COLLECTION, PROMISED
GIFT OF RONALD AND MAXINE LINDE 16137

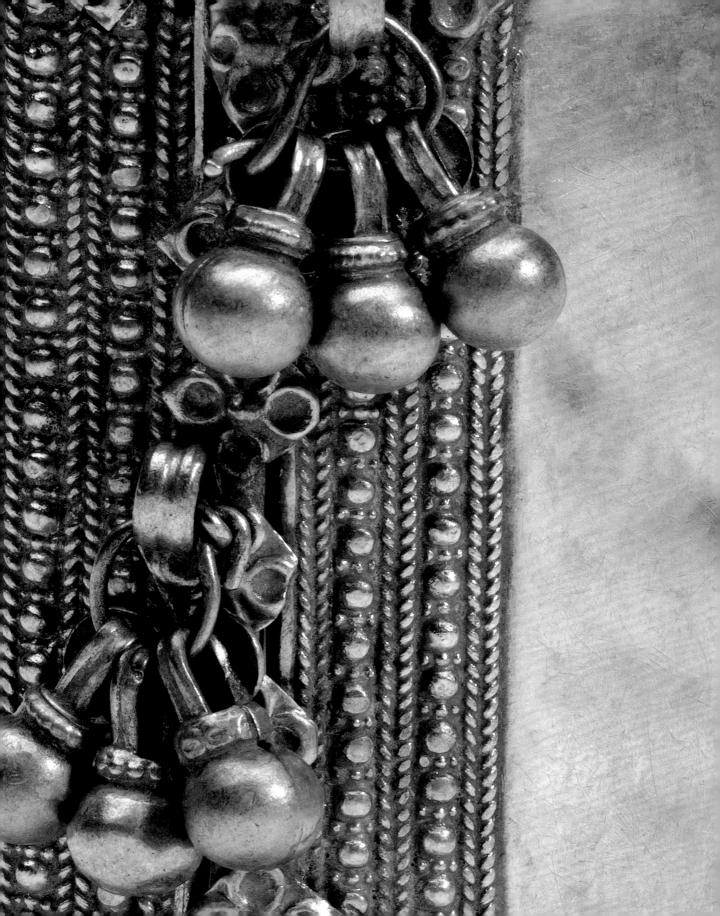

APPENDIX: A SONAR ORIGIN STORY AND TWO STORIES OF GOLD AND GREED
Collected by Thomas K. Seligman in 2012 from Oral Interviews in English

During my fieldwork in Rajasthan and Gujarat, I interviewed over fifty *sonis* about their work and family histories. In addition, I asked about family deities and about any stories they might have concerning the origins of the Soni caste or the process of working with gold and silver. In almost all cases the *sonis* could give me an abundance of information about family history and genealogy, their training, clients, and their work specializations, but in very few instances did any *sonis* have any idea of what might be termed an origin story or myth about how the *sonis* came into being. The story below from Dhanraj Soni is the only one I was able to obtain that related to the origin of the Soni caste. The two stories from Mahendra Singh illustrate the importance of gold in Indian culture.

A STORY TOLD BY DHANRAJ SONI OF BARMER

A demon wanted to marry the family goddess Jagdamba Mahabhavani [which is also the name of a temple near Barmer]. She didn't resist him, and using the dirt from her body, she made two men [sons]—one a *soni* named Jhalu and the other named Agarwal Jain. She prepared Jhalu to kill the demon, and she knew he could do it. The demon had fingernails of gold, and he was very dirty so Jagdamba Mahabhavani told the demon...that she would marry him only if he cleaned himself. The demon lived in a cave and asked how he should clean himself. Jhalu said he would teach him how to clean himself. Jhalu brought *sogi* or *suaga* [flux?] and put it on the demon's gold fingernails, and he also brought lead [if lead mixes with gold, it ruins the gold]. Jhalu put lead bangles on the demon's upper arm above the elbow and flux on the lead and gold fingernails. Then Jhalu told the demon to bathe in the fire to get clean. The demon died in the fire, and Jhalu salvaged the gold, and this is how the *sonis* came into being. Jhalu taught his family to make ornaments. Later a son married a Brahmin woman and became a Brahmin Soni and was thrown out of the Medh caste.

STORIES TOLD BY MAHENDRA SINGH OF NEW DELHI (A SHOP OWNER DEALING IN ANTIQUE JEWELRY)

The king did a puja [prayer], and god said he could have whatever he wished, and the king asked that whatever he touched would turn to gold. God granted him his wish, and he became very wealthy, but one day he accidentally touched his daughter who became a gold statue. The king was devastated and realized that being greedy was not good.

A poor man heard that gold attracts gold. He worked hard and managed to get a gold coin. He then snuck into the king's palace past the guards to get to the treasury. Through the bars of the treasury, he could see piles of gold and jewels. He held out his gold coin and tried to attract the gold from the treasury, but the coin slipped from his hand and rolled into the treasury and joined the other gold coins. Big money attracts small money.

BIBLIOGRAPHY

Balakrishnan, Usha R.
2015 *Alamkāra, The Beauty of Ornament*. New Delhi: National Museum.

Balakrishnan, Usha R., and Meera Kumar
1999 *Dance of the Peacock: Jewellery Traditions of India*. New Delhi: India Book House.

Balakrishnan, Usha R., Ekaterina Scherbina, Diana Scarisbrick, and Larisa Peshekhonova
2014 *India: Jewels that Enchanted the World*. London: Indo-Russian Jewellery Foundation.

Balakrishnan, Usha R., and Oppi Untracht
2005 *Icons in Gold: Jewelry of India from the Collection of the Musée Barbier-Mueller*. Edited by Laurence Mattet. Paris: Somogy Art.

Benjamin, Walter
1986 *Illuminations*. Edited by Hannah Arendt. Translated by Harry Zohn. New York: Schocken.

Borel, France
1994 *The Splendour of Ethnic Jewelry: From the Colette and Jean-Pierre Ghysels Collection*. London: Thames and Hudson.

Brijbhushan, Jamila
1964 *Indian Jewellery, Ornaments, Decorative Designs*. Bombay: Tara-porevala.

Brouwer, Jan
1989–1990 *The South Indian Blacksmith and Goldsmith: The Visvakarmas' View on Iron and Gold*. Indologica Taurinensia xv–xvi, 91–104. www.indologica.com.

Chaturvedi, B. K.
1991 *Jewellery of India*. New Delhi: Diamond Pocket Books.

Coomaraswamy, Ananda K.
1909 *The Indian Craftsman*. London: Probsthain.

Craddock, Paul, et al.
2013 "Simple Sophistication: Mauryan Silver Production in North West India." *Technical Research Bulletin* 7 (The British Museum): 79–93.

Dhamija, Jasleen, ed.
2010 *Berg Encyclopedia of World Dress and Fashion: South Asia and Southeast Asia*. Vol. 4. Oxford: Berg.

Ganguly, Waltraud
2007 *Earring: Ornamental Identity and Beauty in India*. Delhi: B. R.

George, Varghese K.
2003 "Globalisation Traumas and New Social Imaginary: Visvakarma Community of Kerala." *Economic and Political Weekly* 38, no. 45 (Nov. 8–14): 4794–802. www.jstor.org/stable/4414253.

Griffith, Ralph, T. H., trans.
1896 "Hymns 81 and 82." *The Hymns of the Rig Veda*. 2nd ed. Bk. 10. Benaras: E. J. Lazarus. http://www.sacred-texts.com/hin/rigveda/index.htm.

Hendley, Thomas H.
1995 *Indian Jewellery*. Repr. ed. Delhi: Low Price.

Kaul, Aarttee,
N.d. "Virah in the 'Mand' Gayaki of Rajasthan: Total Victory in Total Surrender, The Desert Singers." https://www.academia.edu/5475522/Virah_In_The_maand_Gayaki_of_Rajasthan_Total_Victory_in_Total_Surssender_The_Desert_Singers.

Kenoyer, Jonathan Mark
1991 "Ornament Styles of the Indus Valley Tradition: Evidence from Recent Excavations at Harappa, Pakistan." *Paléorient* 17, no. 2: 79–98. http://www.persee.fr/web/revues/home/prescript/article/paleo_0153-9345_1991_num_17_2_4553.

Misra, R. N.
2011 "Silpis in Ancient India: Beyond Their Ascribed Locus in Ancient Society." *Social Scientist* 39, no. 7/8 (July-August 2011): 43–54. www.jstor.org/stable/41289419.

Moore, Alvin, and Rama P. Coomaraswamy
1988 *Selected Letters of Ananda K. Coomaraswamy*. Delhi: Indira Gandhi National Center for the Arts and Oxford University Press.

Neubauer, Jutta
2001 *Chandrika, Silver Ornaments of India*. New Delhi: Shisha, Manchester, in Association with Timeless.

Possehl, Gregory L.
2002 *The Indus Civilization: A Contemporary Perspective*. Walnut Creek, CA: Altamira, Rowman and Littlefield.

Roe, Sir Thomas
1899 *The Embassy of Sir Thomas Roe to the Court of the Great Mogul, 1615–1619, as Narrated in His Journal and Correspondence*. Edited by William Foster. London: Hakluyt Society.

Shukla, Pravina
2005 "The Study of Dress and Adornment as Social Positioning." *Material History Review* 61 (Spring): 4–16.

Star, Rene Van der
2002 *Ethnic Jewellery: From Africa, Asia and Pacific Islands*. Amsterdam and Singapore: Pepin.

Stronge, Susan, and Nima Smith.
1998 *A Golden Treasury: Jewellery from the Indian Subcontinent*. New York: Rizzoli in Association with the Victoria and Albert Museum and Grantha.

Thurston, Edgar
2001 *Castes and Tribes of Southern India*. Vols. 1–7. New Delhi: Asian Educational Services.

Tod, James, and William Crooke.
1920 *Annals and Antiquities of Rajasthan; or, The Central and Western Rajput States of India*. London: H. Milford, Oxford University Press.

Untracht, Oppi
1997 *Traditional Jewelry of India*. New York: Harry N. Abrams.
2005 "The Indian Goldsmith." *Icons in Gold: Jewelry of India from the Collection of the Musée Barbier-Mueller*. Edited by Laurence Mattet. Paris: Somogy Art.

CONTRIBUTORS

THOMAS K. SELIGMAN is the Freidenrich Director Emeritus of the Cantor Arts Center at Stanford University (1991–2011). After completing his education at Stanford University and the School of Visual Arts, New York, he joined the Peace Corps and served in Liberia where he directed a museum of African Art and taught at Cuttington University. From 1971 until 2007, he conducted fieldwork among the Tuareg of Mali and Niger, culminating in the publication *The Art of Being Tuareg: Sahara Nomads in a Modern World* (2006), which accompanied an exhibition of the same name held at the Fowler Museum and the Cantor Arts Center. In 2008 Seligman began research on the *sonis* of western India, leading to the present volume and exhibition. He retired from Stanford University in January 2016. Seligman is a long-serving Trustee of The Christensen Fund, focusing on supporting indigenous peoples.

USHA R. BALAKRISHNAN is a freelance scholar based in Mumbai, India. After obtaining a post-doctorate degree in Museum Studies at New York University, she worked as a research associate at the Brooklyn Museum, where with a grant from the Hagop Kevorkian Fund, she steered a project documenting Mughal jades and inlaid jades around the world. Her publication *Dance of the Peacock: Jewelry Traditions of India* (1999) reflects her research on the five-thousand-year history of Indian jewelry. In 2001 the Government of India invited her to study the fabulous collection of gems and jewelry that formerly belonged to the Nizams of Hyderabad. Her book *Jewels of the Nizams* is the only publication on this renowned royal collection. Her other publications include *Icons in Gold: Jewelry of India from the Collection of the Musée Barbier-Mueller* (2005) and *Splendours of the Orient: Gold Jewels from Old Goa* (2014). In 2014 she was invited to guest curate the exhibition *India: Jewels That Enchanted the World* at the Kremlin Museum, Moscow, and contributed essays to the accompanying catalog. The same year, she curated an exhibition of the permanent collection of Indian jewelry at the National Museum, New Delhi, *Alamkāra: The Beauty of Ornament*, and authored the catalog. Balakrishnan is currently working on several research projects including a definitive study of Golconda Diamonds.

FOWLER MUSEUM AT UCLA

DONORS

Major support for this project has been provided by
C. Diane Christensen

with additional support from
The Anawalt Program for the Study of Regional Dress
Endowment Fund

An Anonymous Donor

Avrum and Martha Bluming

and funding in part for the publication only by
The Ahmanson Foundation, on the recommendation
of Foundation Trustee Emeritus, Lloyd E. Cotsen

The Fowler Museum is part of UCLA's School
of the Arts and Architecture

Lynne Kostman, *Managing Editor*
Gassia Armenian, *Editorial Assistant*
Danny Brauer, *Designer and Production Manager*
Don Cole, *Photographer*

Fowler Museum at UCLA
Box 951549
Los Angeles, California 90095-1549

Requests to reproduce material from this volume should be sent to
the Fowler Museum Publications Department at the above address.

Printed and bound in Hong Kong by Great Wall Printing Company, Ltd.

The fonts used in this publication include typefaces from
Indian Type Foundry, Ahmedabad, India.

Text: Deccan by Ramakrishna Saiteja
Headings and captions: Akhand Soft by Satya Rajpurohit

indiantypefoundry.com

Library of Congress Cataloging-in-Publication Data

Names: Bala Krishnan, Usha R. (Usha Ramamrutham) | Seligman,
 Thomas K. | Fowler Museum at UCLA, organizer, host institution.
Title: Enduring splendor : jewelry of India's Thar Desert / Seligman
 and Balakrishnan.
Other titles: Enduring splendor (Fowler Museum at UCLA)
Description: Los Angeles : Fowler Museum at UCLA, 2017. | Includes
 bibliographical references.
Identifiers: LCCN 2016033274 | ISBN 9780990762645 (pbk.)
Subjects: LCSH: Jewelry—Thar Desert (India and Pakistan)—Exhibitions.
Classification: LCC NK7376.A3 T49 2017 | DDC 739.270954/4—dc23
LC record available at https://lccn.loc.gov/2016033274

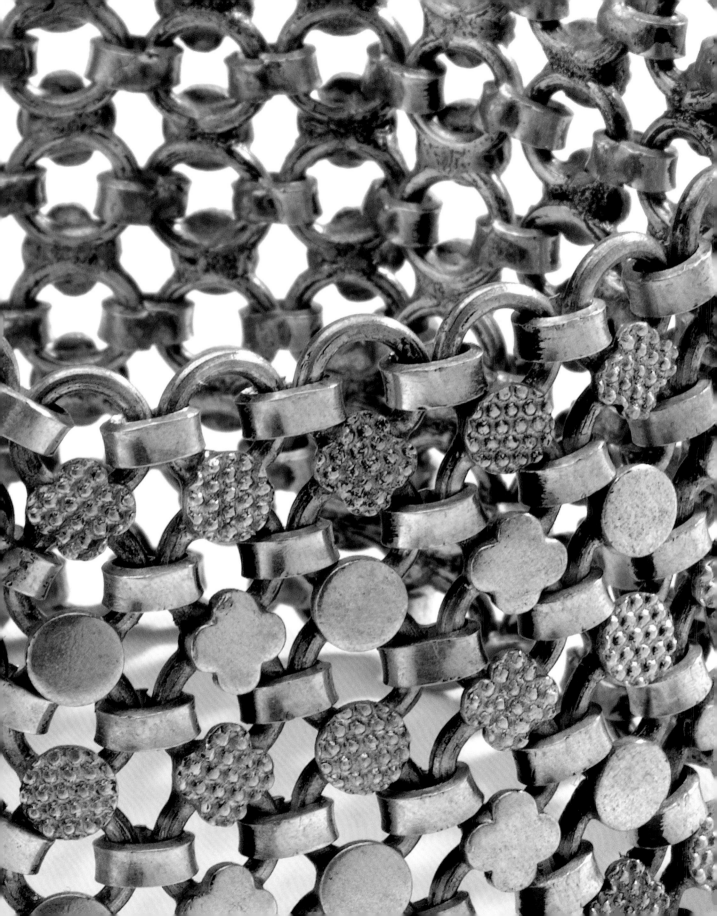